IMAGES
of America

GUILFORD

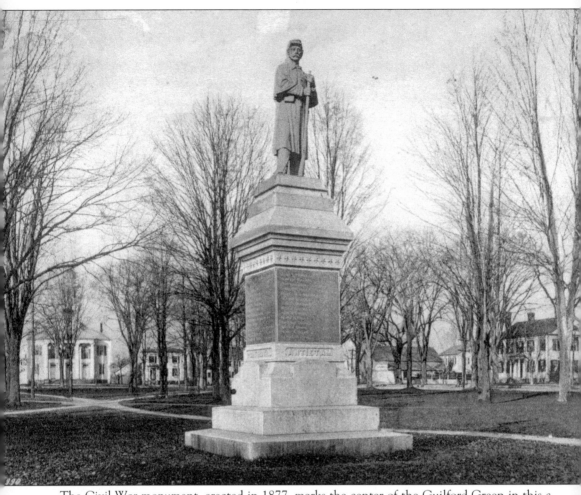

The Civil War monument, erected in 1877, marks the center of the Guilford Green in this *c.* 1905 image.

On the cover: Jones Bridge is the southernmost route over the West River. This is how it appeared in 1890. A new bridge replaced this one in 1910, and the present bridge dates from 1981.

IMAGES
of America

GUILFORD

Guilford Keeping Society

ARCADIA

First printed in 2001.

Published by Arcadia Publishing,
an imprint of Tempus Publishing, Inc.
2A Cumberland Street
Charleston, SC 29401

Printed in Great Britain.

Library of Congress Catalog Card Number: 00-104073

For all general information contact Arcadia Publishing at:
Telephone 843-853-2070
Fax 843-853-0044
E-Mail sales@arcadiapublishing.com

For customer service and orders:
Toll-Free 1-888-313-2665

Visit us on the internet at http://www.arcadiapublishing.com

*This book is respectfully dedicated to the Guilford Keeping Society Library Committee,
which has been preserving and cataloguing Guilford photographs for more than 25 years;
to Shelton W. Dudley Sr., who collected and catalogued negatives from Guilford
photographers for nearly 50 years; and to Grace Dudley,
who gave her husband's collection to the Guilford Keeping Society.*

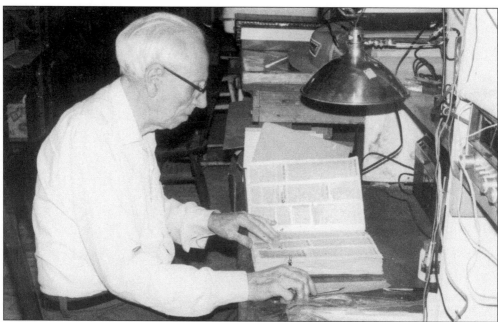

Shown is Shelton W. Dudley Sr. (1895–1982). (Joel Helander; used with permission.)

CONTENTS

ACKNOWLEDGMENTS

The Guilford Keeping Society would like to thank the committee that worked on this book: Sandra Rux (chairman), David Grigsby, Keith Harvey, Henry Haskell, Susan Stoddard, and Dorothy Volosin.

We on the committee wish to thank Joel Helander and Deborah Peluse, who as library committee members have both been cataloguing the Guilford Keeping Society collection for more than 25 years. They also located the negatives that we needed to have printed and oversaw the printing process. Without their efforts we would not have been able to put this book together.

We would like to express our appreciation to Edith Nettleton, librarian emeritus of the Guilford Free Library, for indexing issues of the *Shore Line Times* covering over 100 years. This shortened our research time immensely. We also thank the library staff members for their patience as we worked many nights until closing time.

INTRODUCTION

Puritan minister Henry Whitfield and his followers founded Guilford in 1639 as an independent colony. The greatest portion of the town was purchased from Shaumpishuh, sachem squaw of the Menuncatuck band. The Whitfield group purchased additional land on the east from the Niantics. This section of town was known as East Guilford and split off as the new town of Madison in 1826. Guilford became part of New Haven Colony in 1643. When several of the early leaders of the town (including Henry Whitfield) returned to England in the 1650s, William Leete remained as leader. New Haven Colony and the Connecticut Colony (Hartford and the surrounding areas) united in 1664 while William Leete was governor of New Haven Colony. Leete was elected governor of Connecticut in 1676 and continued in office until his death in 1683. Until the election of Rollin Woodruff in 1906, Leete was the only resident to serve as chief executive of Connecticut.

The town grew steadily to a population of more than 2,300 people by 1750. At a time when the largest towns in Connecticut (including New Haven, Norwich, and Hartford) had only about 5,000 people, Guilford was viewed as a significant town. The primary occupation was farming, with a substantial minority engaged in maritime activities. During the American Revolution, most of the residents were patriots. Although no battles were fought in Guilford, there were raids by the British and Tories from Long Island, the most significant of these being the attack on Leetes Island in June 1781.

With a shallow harbor, development of Guilford as a major port was unlikely. The lack of a significant waterpower source precluded large industrial development in the early 19th century. Shoemaking became the major industry in the early 19th century, with 11 shops manufacturing shoes for export. This industry declined, however, as shoemaking was automated in other states. Between 20 and 30 oyster boats harvested oysters in Guilford. The town's oysters, although not numerous, were particularly prized. Various manufacturing firms were established, including the Guilford Manufacturing Company, the American Lock Works, and a papier-mâché factory—all of which failed. The most enduring enterprise was the Spencer foundry, established in the 1850s and operational until 1972.

This volume focuses on the years between 1880 and 1920, when Guilford was a still a small town of nearly 2,800 year-round residents. Located close enough to New Haven for residents to be in frequent contact with urban society, Guilford quickly adopted new amenities while remaining an agrarian town. The Sachem's Head Canning Company and Knowles-Lombard made agriculture profitable by catering to a population that no longer grew most of its own food.

Guilford tomatoes and pumpkins became famous throughout the region. The need for larger fireproof buildings in booming urban centers such as New York increased the demand for stone. Several quarries were established to extract the desirable Guilford granite. This brought an influx of Scandinavian and Italian workers to town, many of whom remained even after the quarries closed. At the same time, an increasingly prosperous middle class began to vacation during the summer. Guilford was an easy journey from most Connecticut cities and possessed a scenic shoreline. It is significant that the quarry workers and the summer residents combined to form the largest influx to the town since the American Revolution.

Guilford attempts to capture some of the excitement of this period. Improvements in photographic processing made it possible to create these images. The automobile, the golden age of the trolley, and the addition of telephone service and electricity made life more comfortable. The summer residents valued the many Colonial houses still standing in town and the picturesque Guilford Green, while the large population of foreign workers raised fears about disappearing culture. These concerns combined to foster an early interest in preservation, with both the Henry Whitfield House and the Hyland House opening as museums in the early years of the 20th century. We have ended our story with 1920 partly because of the overwhelming number of photographs in our collection and partly because the period after 1920 is the story of the development of a Connecticut suburb, which we will leave for a future volume.

The Guilford Keeping Society, founded in 1947, operates the Thomas Griswold House Museum and maintains a large collection of photographs and documents concerning Guilford. Previous publications include *Milestones of Old Guilford* (1953) and *Pictorial Guilford* (1976). The library committee started to catalog photographs in the early 1970s. Images by Harriette Hunt Bryan, Henry S. Davis, and Charles D. Hubbard formed the nucleus of the collection, which consisted of more than 3,000 prints by 1990. It more than doubled in size when Grace Walker Dudley donated her husband's collection of negatives to the Guilford Keeping Society in 1995.

Shelton W. Dudley Sr. began seriously collecting negatives of Guilford photographers in the 1950s and continued until his death in 1982. He graduated from the Bliss Electrical School in Washington, D.C., in 1916 and became the automotive electronics specialist for Norton's Garage, owned by Clarence Norton. During World War I, Dudley served in the U.S. Army Air Service as a radio operator and instructor in radio classes. He continued working at Norton's Garage until World War II, when he began working in the testing laboratory of Echlin Manufacturing in New Haven. After he retired from Echlin in 1970, Dudley devoted himself to the study of Guilford history. It was during this period that he collected and organized the bulk of the negatives. His notes have been invaluable in our cataloging efforts. The Shelton W. Dudley collection contains large numbers of images from Redfield B. West, Oliver B. Husted, Henry S. Davis, as well as negatives for his own photographs. Without his efforts it is unlikely that such a complete photographic record of Guilford would ever have been assembled.

One

THE PHOTOGRAPHERS

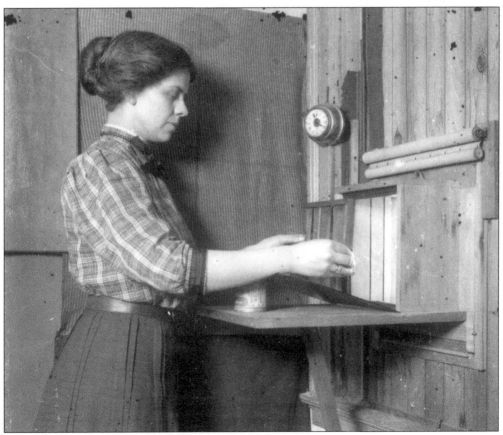

Edith Thrall assisted her cousin Oliver B. Husted with the developing process. She is shown here working in his darkroom. (Oliver B. Husted, c. 1905.)

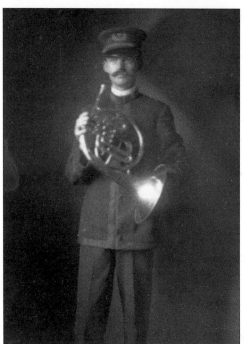

Oliver Brooks Husted (1881–1938) appears here in his Buell's Band uniform, with a French horn. Music and photography were his chief interests. He never married, remaining at home with his parents, Nancy Brooks Husted and Edward G. Husted. He was the grandson of Capt. Oliver Brooks, a well-known Faulkner's Island lighthouse keeper. (Oliver B. Husted, c. 1909.)

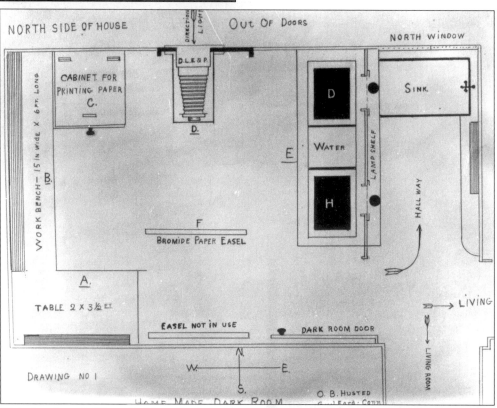

This drawing of Oliver B. Husted's darkroom in his parents' house at 259 Whitfield Street provides insight into the home-designed studios of the period. (Oliver B. Husted, c. 1905.)

10

Henry S. Davis (1898–1978) worked as a
professional photographer for much of his
life. Beginning in 1903, he worked out of
the Kimberly Building. In 1908, he leased
space next to the town hall for a
photographic store. He later operated a
photograph and paint store at 14 Water
Street. (Henry S. Davis, c. 1910.)

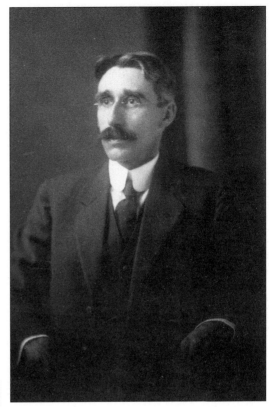

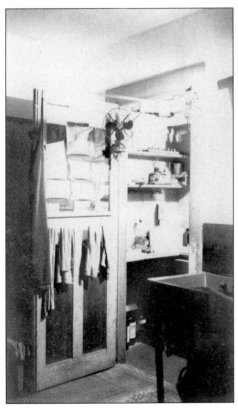

In addition to his photograph store, Henry S.
Davis maintained a darkroom in his home at
320 Boston Street. (Henry S. Davis.)

Redfield B. West (1857–1920) graduated from New York University with a medical degree. He practiced medicine in Boston, New York, New Haven, and Guilford. He also operated a photographic studio in New Haven in the late 1880s. He was appointed state chemist in 1894 and received a letter of patent for improvements in the photographic printing process in 1899 and 1900. Shown here is West's house at 33 Fair Street. (Redfield B. West, c. 1890.)

Harriette Hunt Bryan (b. 1854) was the daughter of Lucy Ann Norton and James Hunt, the proprietors of the Guilford Point House. Most of her photographs were taken between 1884 and 1887. After her marriage to Scott Bryan in 1886, he cut window glass for the plate negatives and she coated them chemically. Her tripod camera had no shutter release, thus requiring a great deal of skill for proper focusing. The birth of her first child ended her days of photography. (Julius Ludovici.)

Two

THE GUILFORD GREEN
AND ARCHITECTURE
AROUND TOWN

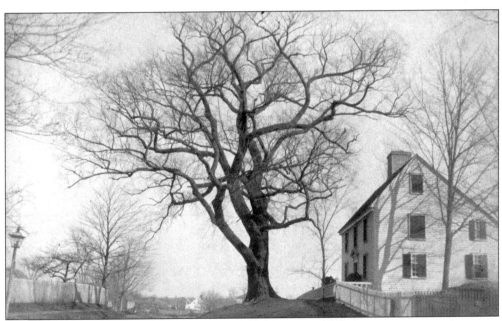

The Guilford Keeping Society operates the Thomas Griswold House as a museum. Built c. 1774 by Thomas Griswold III, the house has been occupied by five generations of the Griswold family. The immense elm tree was known as the "gateway to Guilford" and was a popular subject for photographs, as in this c. 1897 image.

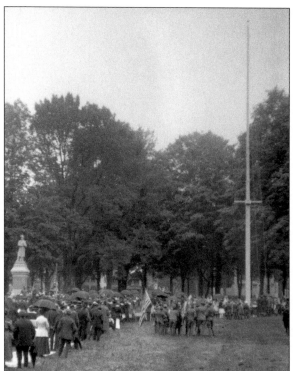

Memorial Day 1918 was the occasion for the dedication of the new liberty pole and flag. Several hundred people gathered for the ceremony. The damp weather caused much difficulty in raising the flag—it had to be sent unfurled to the top of the flagpole, where it then floated in a gentle breeze. (Henry S. Davis, 1918.)

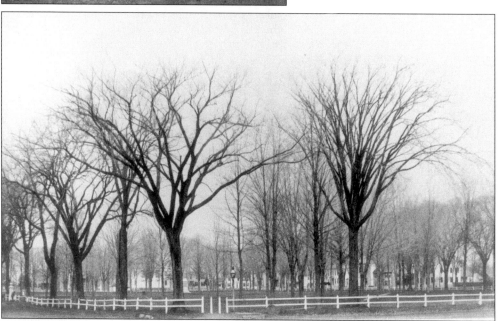

The Guilford Green is shown in 1885. The green assumed this form in 1837, the year the fence was erected and the first Episcopal church, the last building that remained, was removed. Guilford's citizens were inspired by the efforts of those who had beautified the New Haven Green. Although the fence was taken down in 1899 and most of the elms were blown down by the Hurricane of 1938, the Guilford Green remains as a vital and beautiful part of the town. (Harriette Hunt Bryan, 1885.)

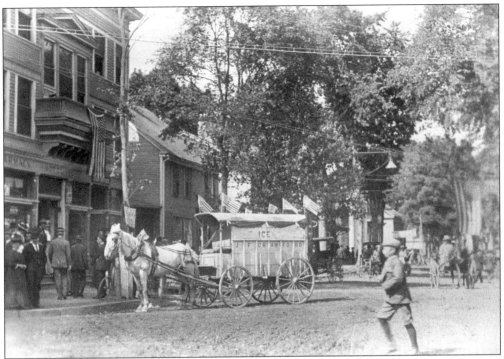

This busy street scene at the corner of Whitfield and Water Streets shows the typical bustling activity of this spot. The photograph was taken between 1902, when the post office moved into the Monroe Building, and 1910, when the Shoreline Electric Railway tracks were laid. J.F. Crawford's wagon is decorated for the Fair Day parade.

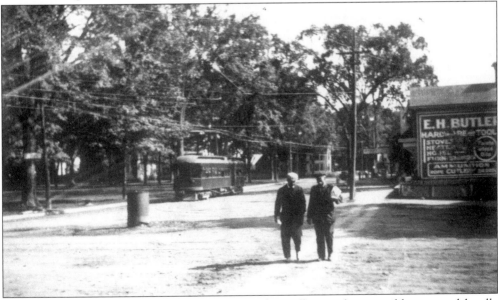

The Shoreline Electric Railroad, also known as the trolley, made it possible to travel locally between Branford and Saybrook. Another trolley line provided easy access to New Haven. The inaugural run of the Shoreline Electric Railroad was on September 22, 1910. The trolley is shown here traveling down Boston Street. (Oliver B. Husted, 1910.)

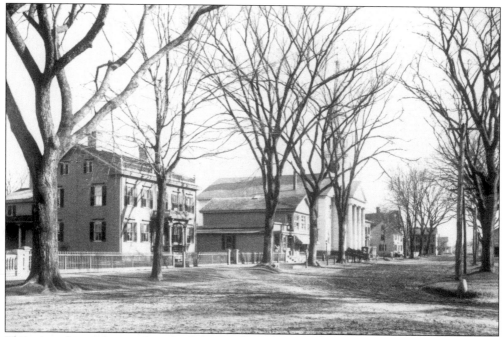

This view shows the north end of the Guilford Green. The house on the left is a greatly modified Colonial house built in 1751 for William Redfield. Next to that house is Griswold's Store, and across Church Street is the Congregational church, built in 1830. (Oliver B. Husted, c. 1905.)

Griswold's Store at 102 Broad Street was built c. 1813 and has remained a commercial establishment ever since. The building was first used as a tavern and "stage house" but was a dry goods store by the 1840s. Edward Griswold and family operated the People's Cash Store here from 1893 until 1981. (Tom Stannard, c. 1910.)

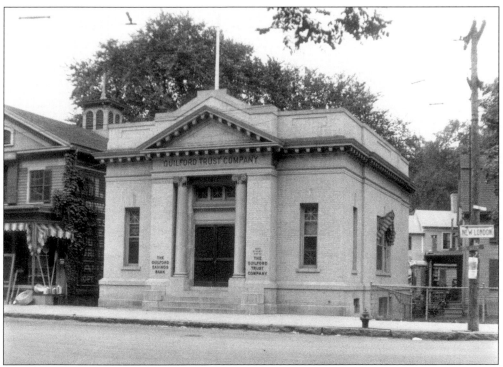

Built in 1912, the Guilford Trust Building, one of the few Beaux Arts buildings in Guilford, housed both the Guilford Trust Company and the Guilford Savings Bank. These institutions shared directors as well as space. (Henry S. Davis, 1912.)

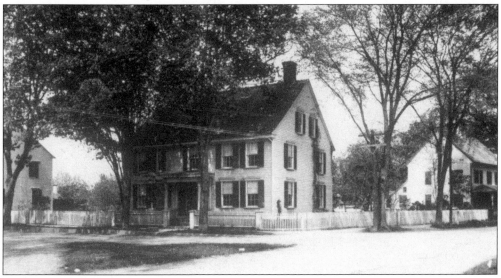

This house, located at the southeast corner of the Guilford Green, was built for John Redfield in 1780 and was later owned by the Landon family. With chimneys at each end, a center hall, and four rooms on each of the two floors, it is typical of the larger homes built in the 1780s. It is now the headquarters of the Guilford Savings Bank. The house on the far right was built for Nathaniel Bishop in 1755 and has since been moved to 147 Boston Street. (Oliver B. Husted, c. 1907.)

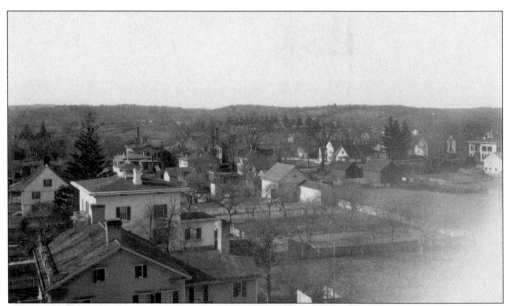

This aerial view of Broad and Fair Streets was taken from the belfry of the First Congregational Church. Note the remarkable number of outbuildings associated with the houses. (Henry S. Davis, *c.* 1915.)

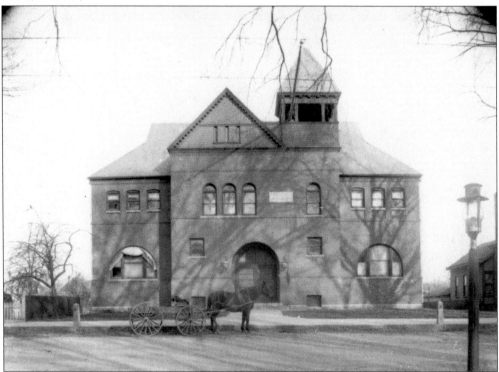

Guilford's town hall, built in 1893, housed the town offices and a 500-seat hall, with a stage and dressing rooms. The building was remodeled in the Colonial Revival style in 1947. In this *c.* 1907 scene, the horse and wagon is still the primary form of transportation and the Guilford Green is still lit by gas. (Oliver B. Husted.)

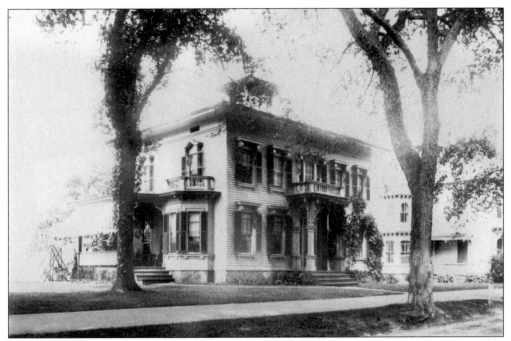

Julie Labadie hired William Weld to build this house after her previous one burned in the fire of 1872. The building is now the rectory of St. George's Roman Catholic Church. (Oliver B. Husted, *c.* 1907.)

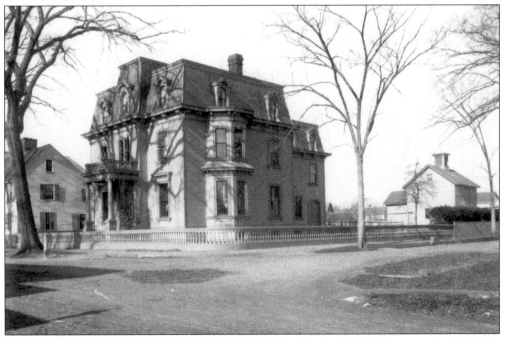

Henry Austin designed this house in the fashionable French Second Empire style for Elisha Chapman Bishop, a Guilford native who earned his fortune in the Titusville, Pennsylvania oil boom. The house was built in 1874 at 122 Broad Street. The First Congregational Church now owns it. (Oliver B. Husted, *c.* 1905.)

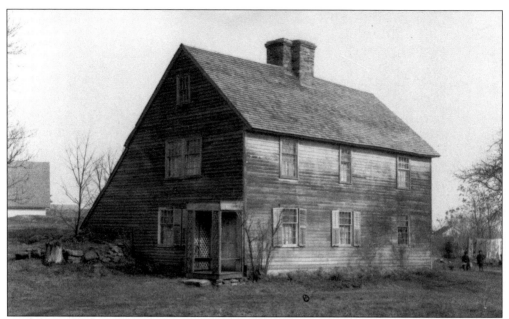

One of the oldest buildings in Guilford, the structure at 37 Union Street is known as the Acadian House. Acadians lived there as refugees from Canada in the 1750s, after France lost the French and Indian War. The house may have been built as early as 1670 for Joseph Clay and his wife, Mary Lord. Toward the end of the 19th century, the front door was moved to the gable end. (Oliver B. Husted, *c.* 1905.)

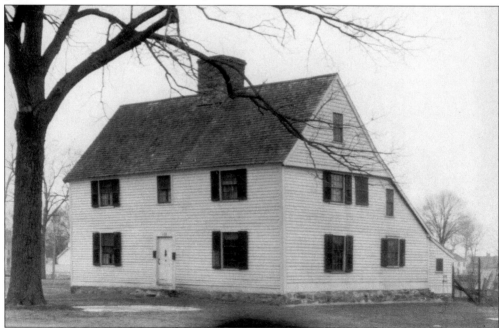

The Kingsnorth-Starr House, located at 138 State Street, was once thought to date to 1645 but is now believed to have been built by Comfort Starr *c.* 1693. The lean-to is an 18th-century addition. This 1915 photograph shows how few changes had been made in the intervening centuries. (Henry S. Davis.)

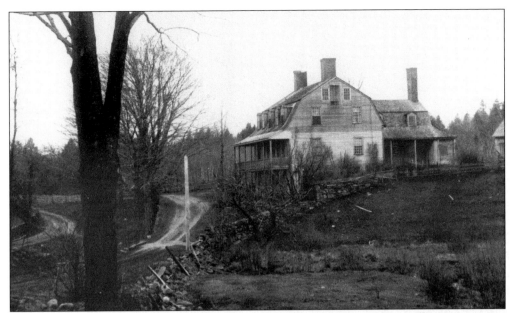

Larger than many Guilford houses, this one at 197 Three Mile Course was built by Medad Stone in 1803 to be used as a tavern. There were plans afoot to locate the main road (now U.S. Route 1) going past this location and across the marsh to connect with Broad Street. Since this did not happen, the building was used as a residence. The kitchen at the rear of the building was built for Faulkner's Island but was never taken there because by the time it was completed, Stone had sold the island to the federal government. (Henry S. Davis, c. 1915.)

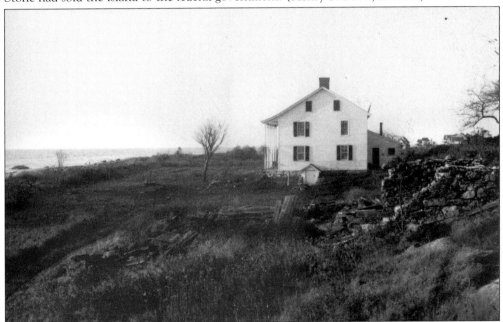

Built by Daniel Brown Leete in 1816, this stylish house was located on a remote farm at Sachem's Head. Jackalow, a Japanese cook and deckhand, murdered two sons of Daniel Brown Leete while on a voyage on Leete's sloop, *Spray*. Leete had mortgaged the farm to pay for the voyage and lost ownership as a result. (Henry S. Davis, c. 1915.)

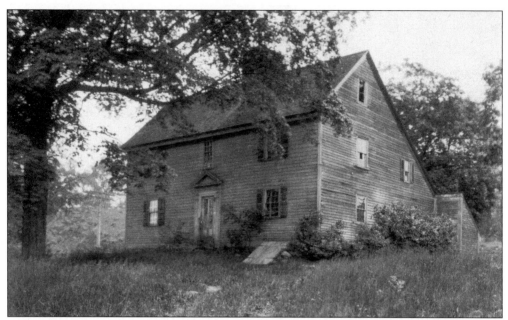

Shown in this c. 1920 image is the oldest of the Leete houses on Leetes Island. It is an integral lean-to saltbox, typical of houses built in Guilford during the mid-18th century. The first occupants were Pelatiah III and Simeon Leete, sons of Pelatiah Leete II. Simeon Leete died here after being wounded in the British raid of Leetes Island in 1781. Rented to various tenants during the early 20th century, the house remained in Leete ownership until 1929.

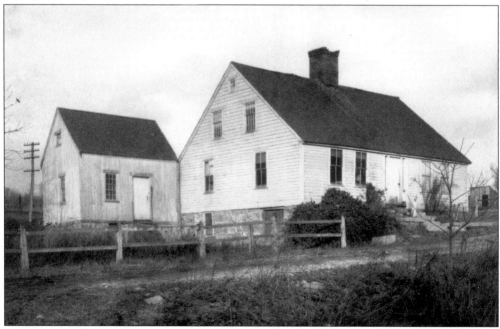

Pelatiah Leete III built this house on Leetes Island in 1796 for his second wife. Two of his three sons and their families remained in the old homestead. While this house was smaller than Leete's first house next door, it represented an opportunity for greater privacy. Visible on the left is Leete's joinery shop. (Oliver B. Husted, c. 1905.)

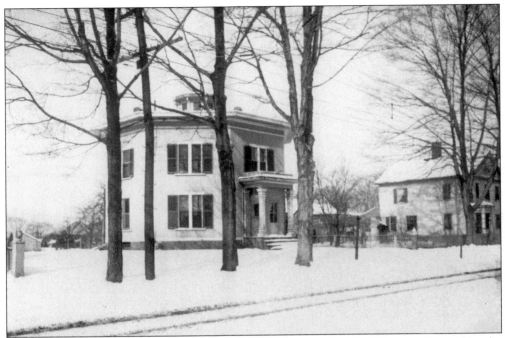

In 1856, Edwin A. Leete built the only octagonal house in Guilford. Born and reared in the second Pelatiah Leete III house, he lived here at 84 Fair Street for only a few years before building a larger house at the corner of Fair and York Streets. (Henry S. Davis, *c.* 1915.)

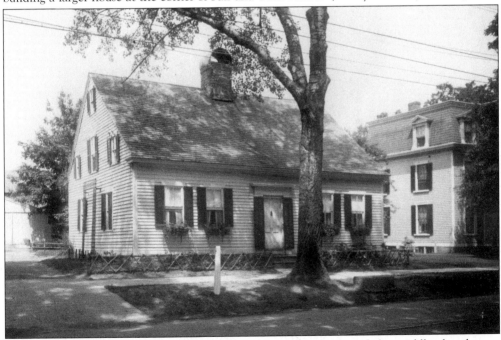

This Cape Cod–style house at 96 Fair Street is representative of the middle-class houses constructed in Guilford after the American Revolution. Built for Abraham Woodward in 1785, the house was later owned by Eva B. Leete and her husband, Edward Leete. Edwin A. Leete's second house appears on the right. (Henry S. Davis, *c.* 1915.)

James Norton built this small Italian villa at 73 Fair Street in 1856. This is one of the few houses built in Guilford in this style and the only one with a stuccoed exterior. When viewed with the neighboring octagonal house across the street (built the same year), residents must have felt that modern architecture was taking over. This photograph dates from 1911.

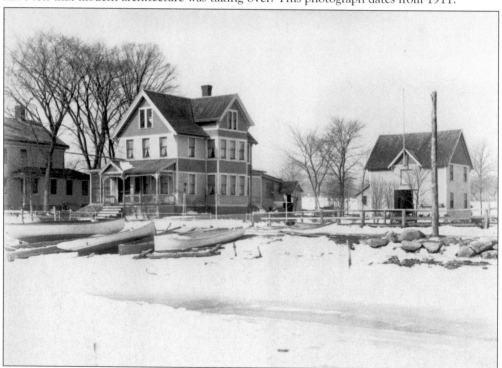

Frank O. Blatchley built this house at 201 Water Street near the West River in 1892. Note how tastes and styles in residential houses have changed compared to the 17th- and 18th-century saltboxes and Colonials and even the mid-19th-century Italianates. (Oliver B. Husted, c. 1905.)

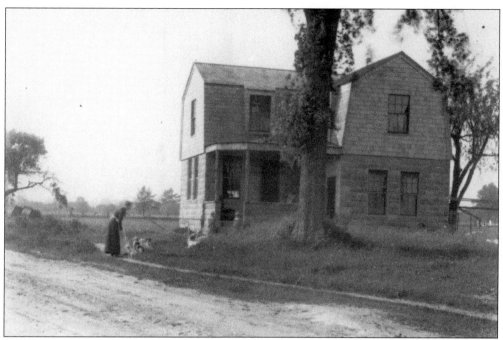

This Dutch Colonial house was built with concrete blocks at 168 Union Street *c.* 1905, showing that Guilford could keep up with the latest in both building materials and the Colonial Revival style. (Oliver B. Husted, *c.* 1905.)

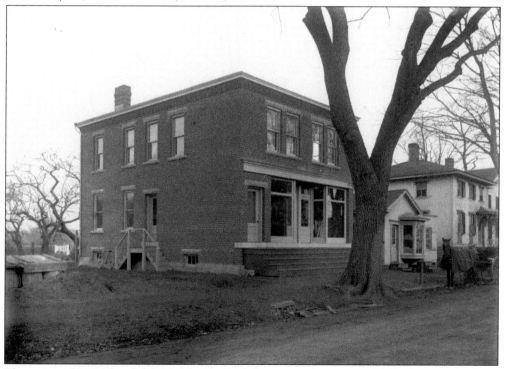

The more urban style of this two-family brick house was unique in Guilford. It was built for John Rossi in 1908. (Henry S. Davis, *c.* 1915.)

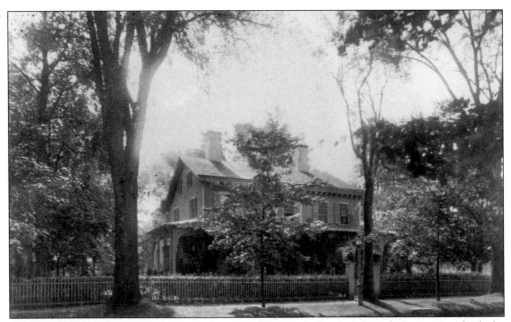

One of Guilford's first Federal-style houses, this structure at 1 Broad Street was built by Abraham Coan for Abel Chittenden in 1804. It stands on the site of the original Chittenden house, built in 1639. In the late 19th century, Simeon B. Chittenden used this as a summer estate. (Oliver B. Husted, c. 1905.)

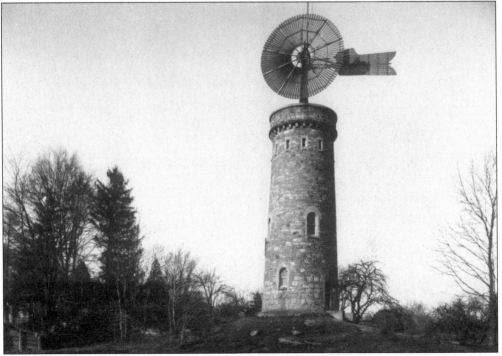

Simeon B. Chittenden built this unique structure as a water tower to supply his summer estate. The tank held 4,000 gallons of water. The windmill was removed after the town established its water system in 1915. (Oliver B. Husted, c. 1909.)

Three

COMMUNITY ACTIVITIES
AND RELIGIOUS LIFE

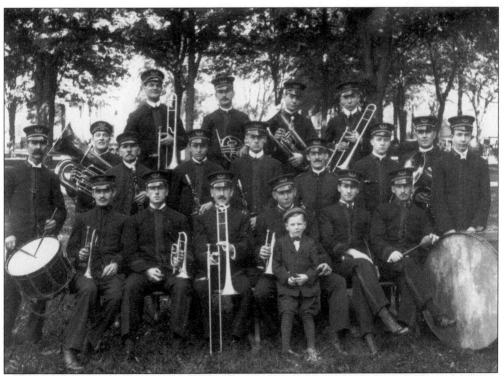

The young men of the town joined together to form Buell's Band in 1907. In this photograph taken that year, David Parmelee holds a trumpet in the front row, the small boy leaning on Warren Jillson's knee is Merle Jillson, and George F. Jillson stands in the back row on the right with a trombone. Oliver B. Husted, who took this picture, played the French horn in the band.

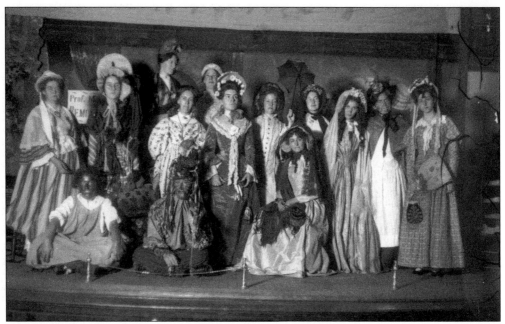

Some 20 ladies of the town staged *The Old Maids Convention* in June 1904 to raise money for Native Americans in the western states. Mary Munson directed. The major attraction of the evening was the transforming machine of Professor Makeover—guaranteed to transform the homeliest old maid into almost anything desired. (Henry S. Davis, *c.* 1904.)

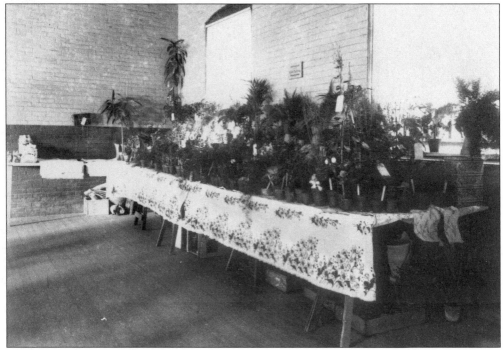

In addition to town meetings and local theatricals, the town hall auditorium was the favored site for charitable bazaars. This plant sale was probably part of a larger bazaar held by one of the churches. (Oliver B. Husted, *c.* 1909.)

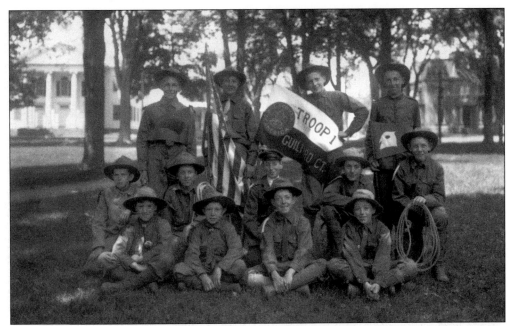

Henry S. Davis was the leader of Boy Scout Troop 1. Arthur Ross is second from the left in the front row, and Irving Dudley is third from the left in the back row. (Henry S. Davis, *c.* 1915.)

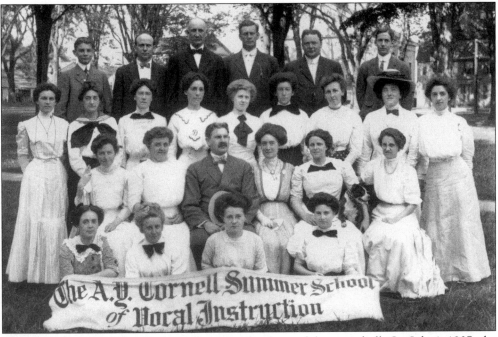

Prof. A.Y. Cornell of New York ran a music school out of the town hall. On July 4, 1907, the *Shore Line Times* advertised, "All persons interested in the study of good choral literature are invited to join in the organization of a chorus which will produce Gounod's motette 'Gallia' and Rossini's 'Stabat Mater' on August 15 for the benefit of the United Workers for Public Improvement. . . . The entire proceeds will be devoted to curbing of the Green." (Oliver B. Husted, *c.* 1907.)

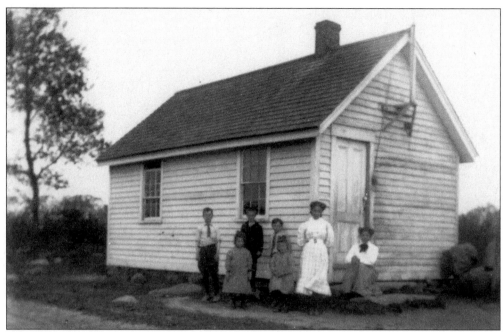

Students and teachers are standing in front of the Sachem's Head schoolhouse on Colonial Road. Note that the schoolhouse is limited to a small plot between the road and stonewall. (Oliver B. Husted, *c.* 1909.)

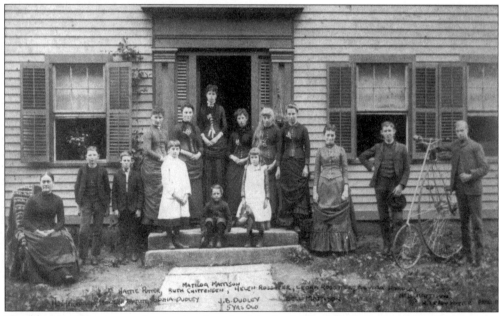

Matilda Mattison ran a private school at the North Guilford Episcopal rectory. She was the daughter of Rev. R.L. Mattison, rector of St. John's Church in North Guilford. She appears here in the doorway at the center of this 1884 photograph. Others shown, from left to right, are her mother, Hosmer Potter, Melzer Bartlett, Hattie Potter, Sophia Dudley, Ruth Chittenden, J.B. Dudley, Helen Rossiter, Bell Mattison, Leora Rossiter, Alvina Hoadley, Nell Mattison, H. Leroy Potter, and Fred Mattison.

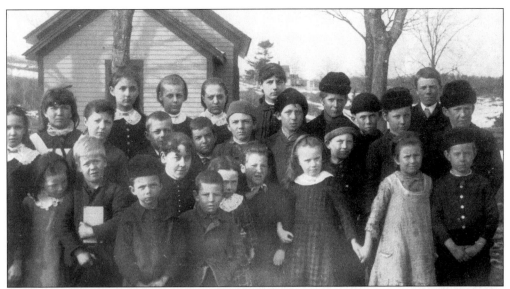

Students of the Leetes Island School pose in 1885. Shown, from left to right, are the following: (front row) Willie Anderson, Burdetta Leete, Abbie Leete (teacher), Mary Bergen, Mary Dolan, Huldah Anderson, and Kate Dougherty; (middle row) Josephine Leete, Sophia Barrett, Park Culson, Wayne Leete, Irving Leete, John Dolan, George Watrous, and Dwight Bartholomew; (back row) Mary Dougherty, Nettie Leete, Sarah Leete, Helen Culver, Fanny Leete, Elmer Anderson, Harry Watrous, and Clarence Leete. (Harriette Hunt Bryan.)

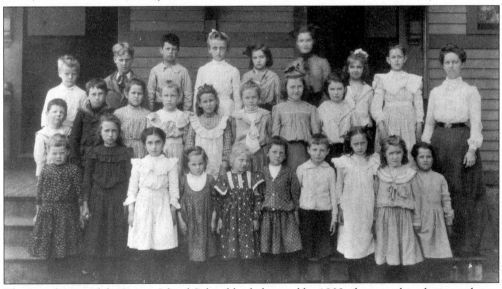

The population of the Leetes Island School had changed by 1902, the year this photograph was taken. That year, Nellie Bell taught the school. Posing here, from left to right, are the following: (front row) Elisabeth Lenholt, Felicity Roise, Nisita DeMatteo, Edith Escott, Amelia Josephson, Marjorie Gay, David Beattie, Alvina Good, Margaret Hackett, and Catherine O'Keefe; (middle row) Joseph Gay, Arthur Sanborn, Margaret Norton, Anna Mattson, Mabel Norton, Nellie Larkin, Mary Hackett, and Irene Beattie; (back row) Gustave Lenholt, Albert Anderson, Raymond Gay, Mabel Bryan, Josephine Beattie, Margaret Beattie, Katherine Bryan, and Elizabeth Norton.

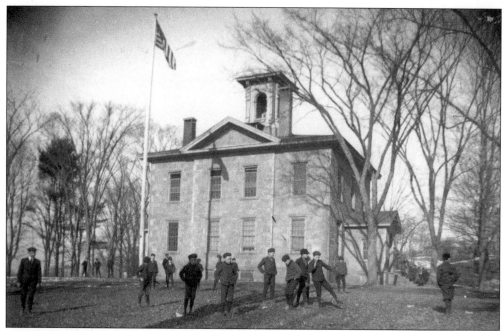

Young men exercise during recess at Guilford's secondary school, the Guilford Institute and High School, which had both male and female students. (Oliver B. Husted, c. 1907.)

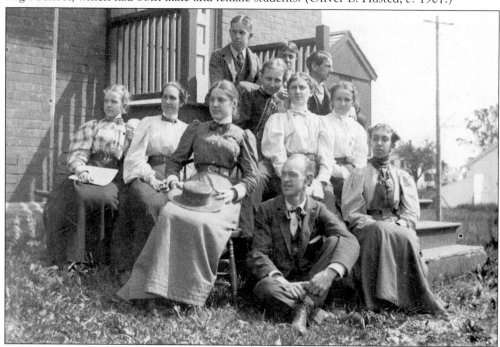

The Guilford Institute and High School graduating Class of 1898 poses at the southeast corner of the town hall. Shown, from left to right, are the following: (front row) Charlotte Griswold, Katherine Shea, Edna Smith, Princifor Hyde, and Susan Burr; (middle row) Florence White, Blairebal Rossiter, and Eunice Sawyer; (back row) Arthur Dudley, Percy Kelsey, and John Dudley.

Although we might think female participation in sports was limited in the early 20th century, this 1910 image of the Guilford High School girls' basketball team indicates otherwise.

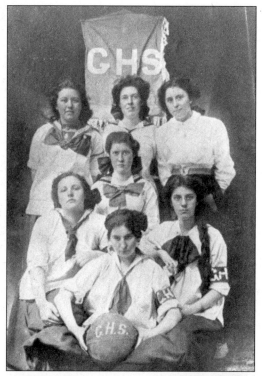

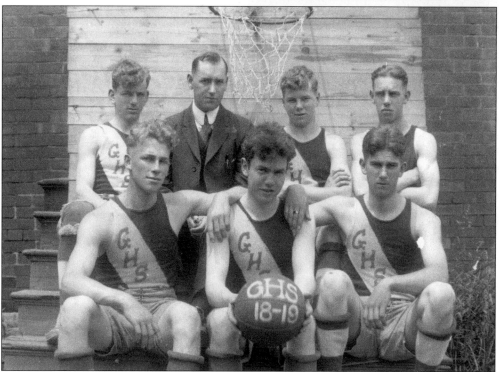

Members of the Guilford High School boys' basketball team pose with their coach in 1918. (Henry S. Davis.)

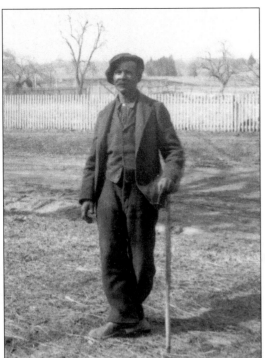

London Butler moved to Guilford with his wife c. 1870. The Butlers built a house on the rocks near the saw pit crossing. Years later, c. 1909, Edward M. Leete helped Butler build a small dwelling near the town mill. One of a small group of African Americans in town, Butler was well known in the community, frequently doing odd jobs and selling clams from the clam flats. He was also a great storyteller, claiming to be 105 years old before his death in 1930. (Oliver B. Husted, c. 1909.)

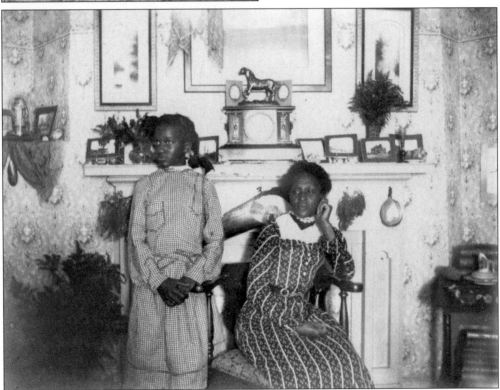

Two girls pose for a portrait, perhaps at the home of their employer. (Oliver B. Husted, c. 1909.)

34

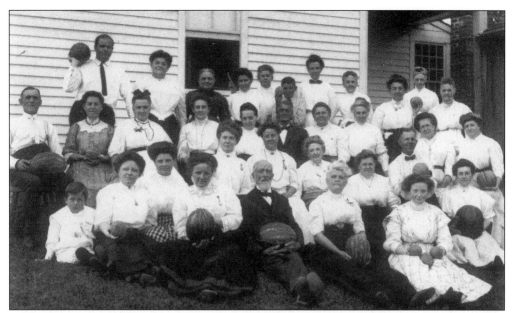

This *c.* 1905 picture shows a family reunion of the Hooker Dudley family held in the Clapboard Hill section of town. Andrew Jackson Dudley, brother of Hooker, is seated in the center front. Perhaps the melons were part of the summer harvest. Hooker Dudley's house was known as Ruttawoo, the Native American name for the East River. (Oliver B. Husted.)

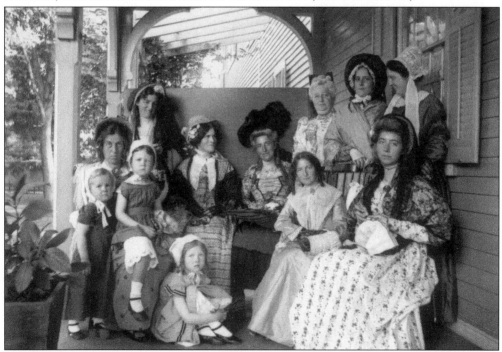

Women of the Simeon B. Chittenden family are shown wearing the clothing of their ancestors, perhaps in honor of the renaming of their old family summer home. The name was changed from Mapleside to Cranbrook, the ancestral home of the Chittendens in England. (Oliver B. Husted, *c.* 1904.)

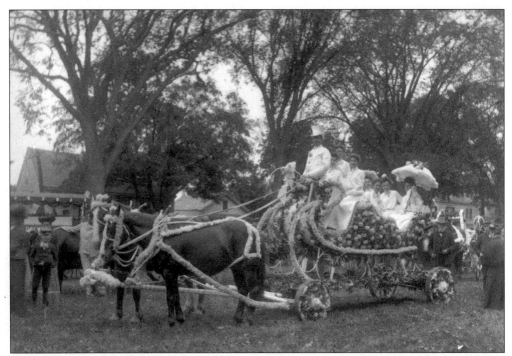

The Guilford Fair was a greatly anticipated annual event. This float from *c.* 1915 may well have been a prizewinner. (Henry S. Davis.)

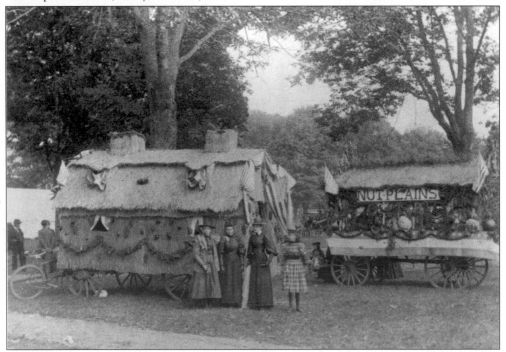

Groups vied with each other to produce the most unusual float. In the foreground of this *c.* 1910 image, the float in the form of a historical house is certainly a superb effort. The Nut Plains float on the right is more subdued.

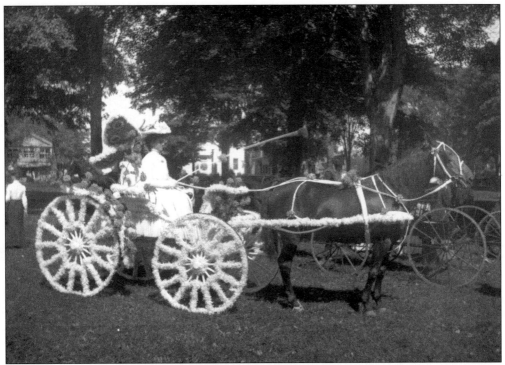

A simple float decorated with flowers waits for the Guilford Fair parade to begin.

Amusements were an important aspect of the Guilford Fair. Pictured is the crew that operated the steam-powered merry-go-round in September 1910. (Thomas Stannard.)

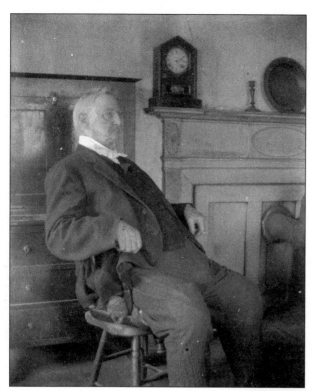

Farmer George C. Griswold
(1809–1906) sits in his parlor at
150 Boston Street. A Democrat in
a Republican town, Griswold held
most of the minority offices at one
time or another. He also served as
clerk of Christ Church for 44
years. (Oliver B. Husted, c. 1905.)

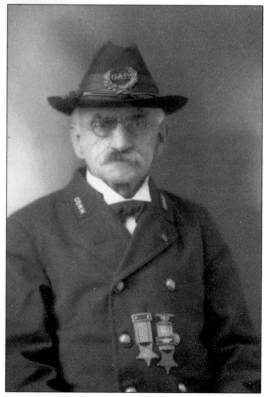

Capt. Charles R. Griswold, one of the last
of Guilford's Civil War veterans, wrote of
his experiences at the fall of Richmond in
1865 for the 50th anniversary of the
event. (Henry S. Davis, c. 1915.)

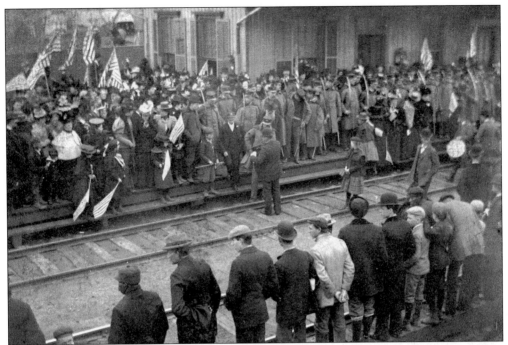

One of the largest gatherings of residents in the late 19th century was the send-off of the Battery Boys for camp at Niantic in preparation for the Spanish-American War. More than 1,500 of Guilford's 2,500 citizens attended the event, which included a parade from the Guilford Green to the railroad station. This image dates from 1898.

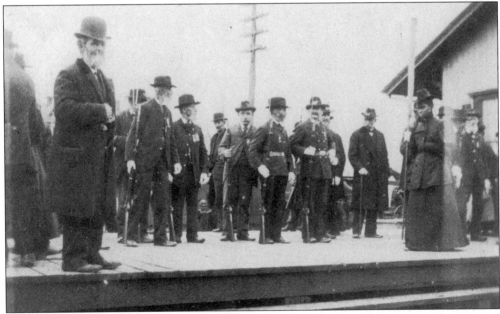

Civil war veterans, including Roger Davis, Mr. Wheatley, Connie Shea, Coxie Sullivan, A.G. Somers, William Hull, and Capt. Charles R. Griswold, were honored guests at the festivities to see off the Battery Boys, who were leaving for service in the Spanish-American War. This is an 1898 photograph.

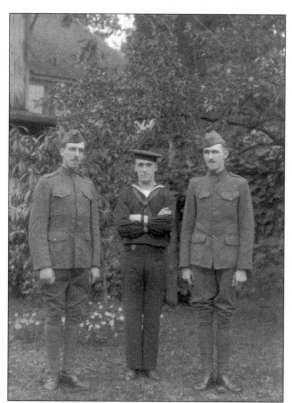

James, John, and William Hubbard are shown shortly before leaving for service in the Great War, later known as World War I. (Henry S. Davis, c. 1915.)

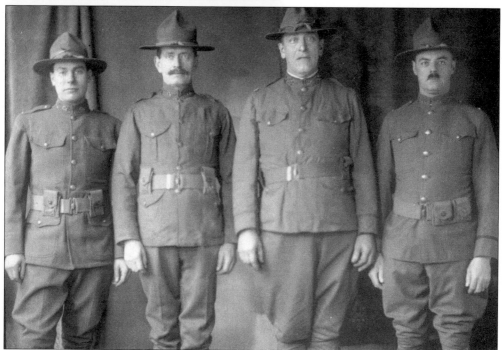

Guilford soldiers are pictured here after their return from World War I. (Henry S. Davis, c. 1920.)

40

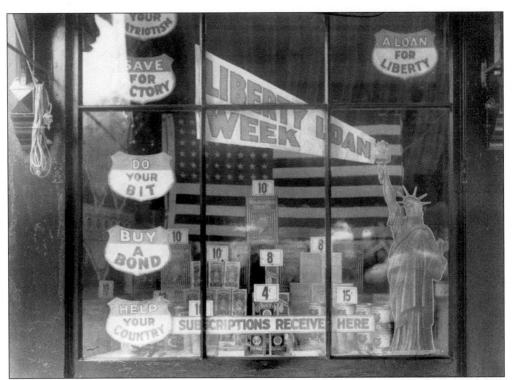

Guilford participated wholeheartedly in the Liberty Loan effort to help finance the "war to end all war." (Henry S. Davis, c. 1918.)

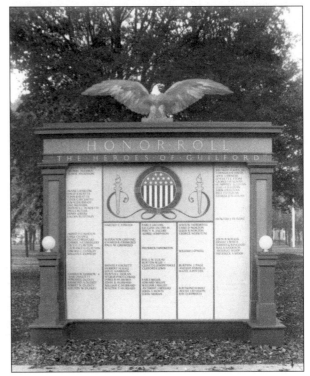

The Great War Honor Roll was prepared by Charles Hubbard and was dedicated on October 17, 1918. It remained on the Guilford Green until a permanent war memorial was completed in 1932. (Henry S. Davis, 1918.)

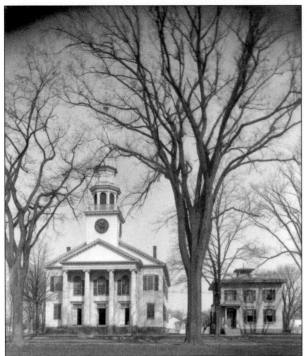

Built in 1830 for $7,500, the current First Congregational Church is the third building owned by the First Society. The builder and architect was Ira Atwater, who was known for several fine buildings in New Haven. When built, this was the grandest meetinghouse on the shoreline. The bell (first cast in 1725) and the clock (assembled by Ebenezer Parmelee in 1776) were reused from the previous meetinghouse. (Henry S. Davis, c. 1915.)

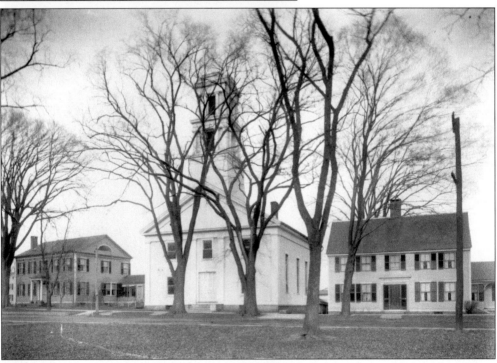

The Third Congregational Church, built in 1884 by the abolitionist faction of the First Society, served its members until 1920, when it was sold to Christ Episcopal Church for use as a Sunday school. The building was was later used as a movie theater and playhouse. It is once again a church, used by the Christian Science congregation. (Henry S. Davis, c. 1915.)

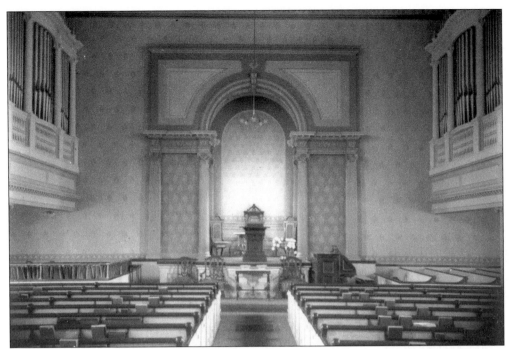

The interior of the First Congregational Church is shown here c. 1915. The pulpit recess and its surround were added in 1898, and the fine organ was installed in 1908. (Henry S. Davis, c. 1915.)

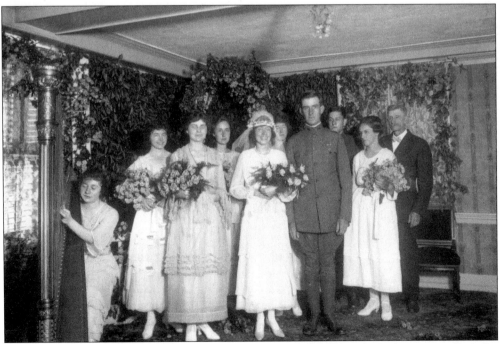

Most weddings were still held at the home of the bride in the early 20th century. Cornelia Forbes was married in her parents' parlor at 199 Whitfield Street in 1917, with roses and a harp accompanist. (Henry S. Davis, 1917.)

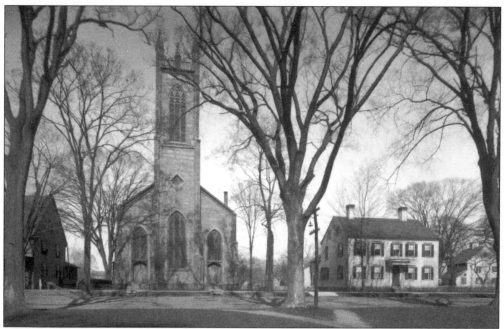

Christ Episcopal Church, completed in 1838, replaced an earlier wooden building on the Guilford Green. Abraham Coan is credited as the builder, but New Haven architect Henry Austin may have executed the design, as vestry records refer to "Austin's Plan." (Henry S. Davis, c. 1910.)

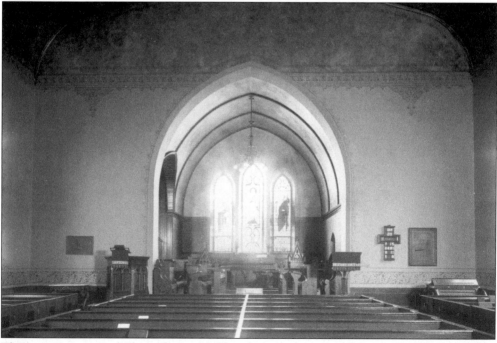

This interior image of Christ Episcopal Church was taken after the 1913 redecoration. The recessed chancel was added in 1872, the electric lighting in 1895 (the first in Guilford), and a new altar in 1909. The Young Ladies Guild funded the 1913 work. (Henry S. Davis, c. 1915.)

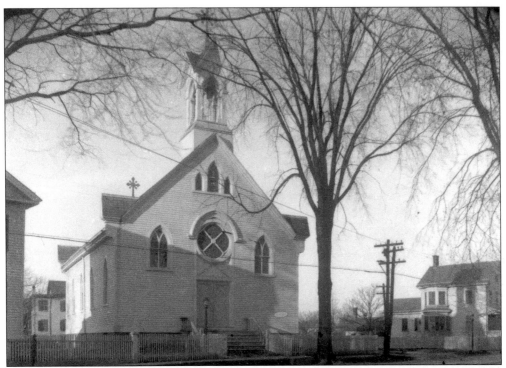

Although the Roman Catholic population of Guilford numbered only about 30 families, they were able to build this fine Carpenter Gothic church in 1876. George Hill, a member of a Guilford founding family, had converted to Catholicism in the 1860s, and the land where the church was built had belonged to the Hill family. (Oliver B. Husted, c. 1909.)

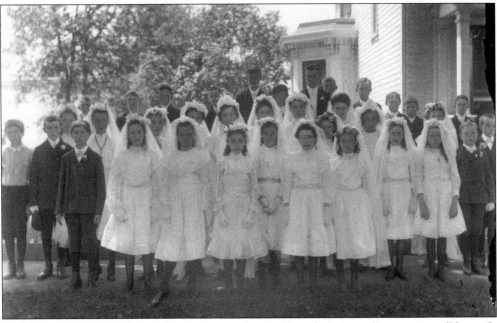

Children of St. George's parish are shown after making their First Communion. (Henry S. Davis, c. 1915.)

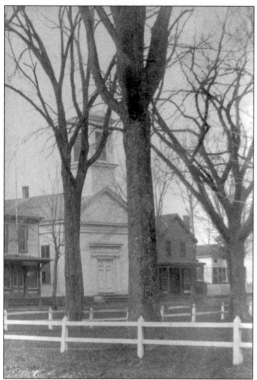

The Methodist Society was formed in 1838 and completed its handsome church in 1839. After the society disbanded in 1920, the church was sold. It was thereafter used primarily for shops. (Harriette Hunt Bryan, *c.* 1885.)

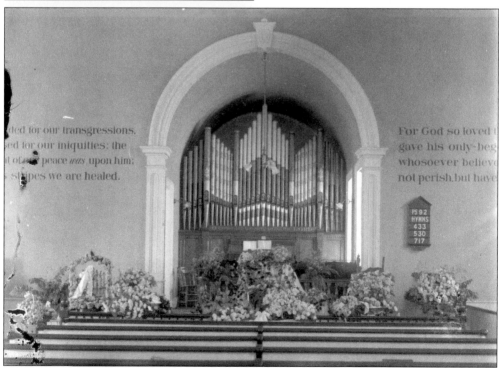

The interior of the Methodist church shows a modern organ and elaborate floral decorations, perhaps for Easter Sunday. (Henry S. Davis, *c.* 1915.)

The Second Society in Guilford was incorporated in 1720 to serve North Guilford. The society's first house of worship was erected in 1723. The North Guilford Congregational Church was erected in 1888, the third building belonging to the society. This image dates from *c*. 1920.

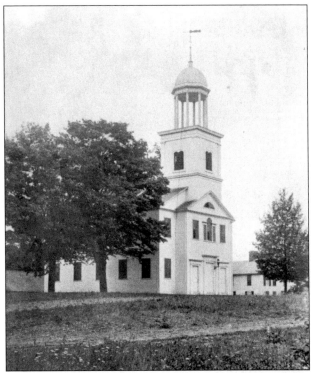

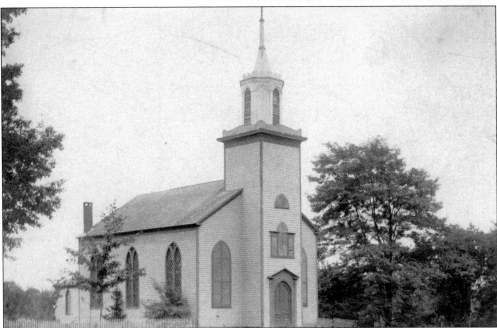

The first parish meeting of St. John's Episcopal Church was held in 1747. By 1754, the congregation had built a church on Meeting House Hill in North Guilford next to the Second Society's church, but shared clergy with Christ Church and other parishes. This structure replaced the earlier one in 1812, making it the oldest of Guilford's church buildings. This image dates from *c*. 1915.

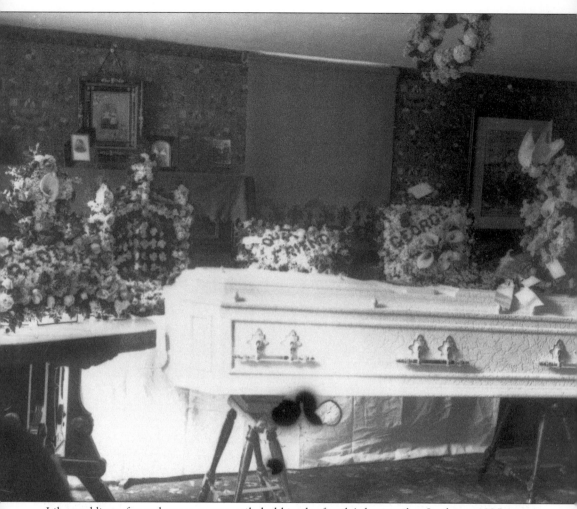

Like weddings, funerals were customarily held in the family's best parlor. In this *c.* 1895 image, George (last name unspecified) is being sent to rest with a splendid floral offering. (Redfield B. West, *c.* 1895.)

Four
SCENIC PATHWAYS

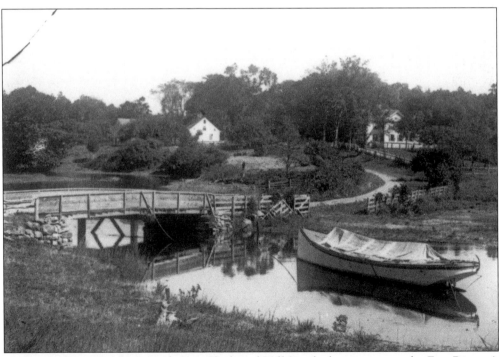

This view shows Howlett's Bridge on Clapboard Hill Road where it crosses the East River. A boat owned by the Parmelee family is moored in the foreground. In the background, the Amos Dudley house is visible on the left, with the William Lee Dudley house on the right. This is still a picturesque area of town, with deer and osprey along the river. (Redfield B. West, *c.* 1895.)

In this view looking north up Long Hill Road, just beyond New England Road, the road curves between James Loper's house and barns. (Henry S. Davis, c. 1918.)

The Eber Lee farm at 1114 Little Meadow Road also shows the typical arrangement of barns on the opposite side of the road from the farmhouse. (Henry S. Davis, c. 1915.)

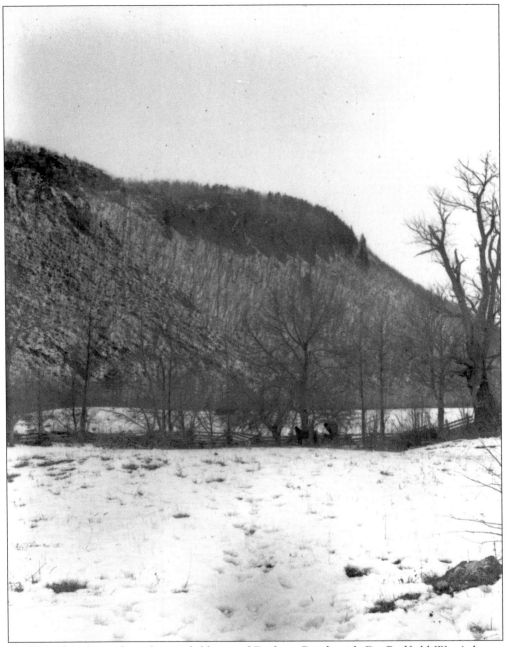

Bluff Head is shown here from a field east of Durham Road, with Dr. Redfield West's buggy visible just past the fence line. This has long been considered Guilford's most dramatic vista. The bluff is the northeastern extremity of Totoket Mountain, which extends for several miles into North Guilford. (Redfield B. West, c. 1895.)

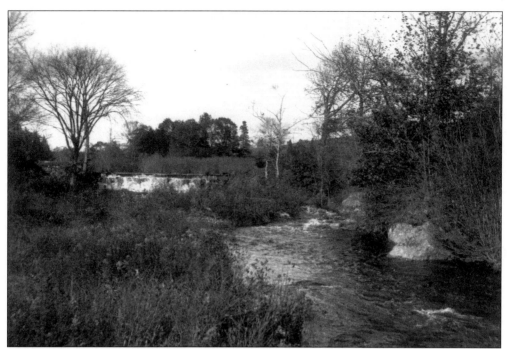

The Mill Pond spillway on Mill Road off of North River Street was in continuous service after *c.* 1658 for the town gristmill, the latest of which was built in 1855. In later years, the spot was a popular picnic area and skating pond. (Redfield B. West, *c.* 1895.)

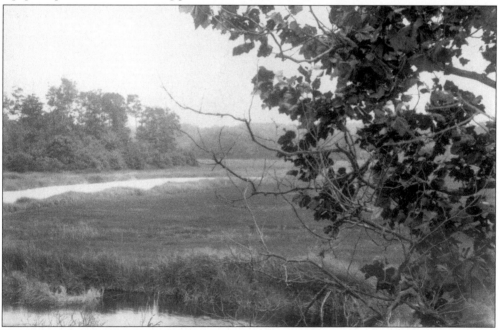

This view shows the East River winding its way from a small stream into a larger tidal river that goes into Long Island Sound. This river still has the feel of a private and peaceful sanctuary. It is now protected by the National Audubon Society and Guilford Land Conservation Trust. (Redfield B. West, *c.* 1895.)

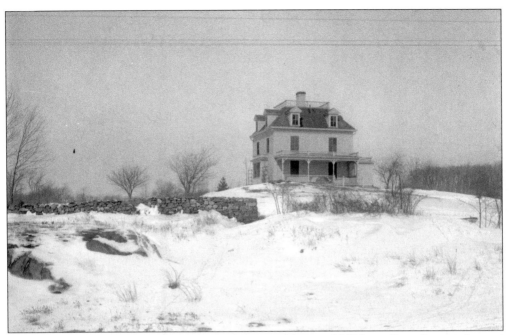

Once owned by H. Milton Bullard Sr., this house and farm at 376 Upper State Street is located in an area known in early times as Great Hill (not to be confused with the Great Hill in North Guilford), even though the elevation is slight. (Henry S. Davis, *c.* 1915)

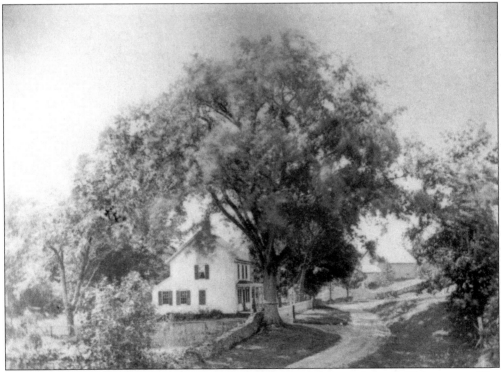

The dirt road in this photograph was typical of all thoroughfares in the early 20th century. The homeowner would have prized the towering elm. (Oliver B. Husted, *c.* 1909.)

The hills around Lake Quonnipaug have always provided excellent vantage points for views of the lake. In this *c.* 1910 scene, two Chittenden houses sit at the end of the lake. To the left is Dudley Chittenden's house, built in 1878. To the right is David Chittenden's house, built in the 1840s. The Durham Turnpike (Route 77) was built on the west side of the lake *c.* 1825. The road around the east side of the lake was a much older one, with several of the early homesteads found along it. A new road in this location is named Scenic View Drive.

This c. 1910 picture was taken looking south on Route 77 toward Lake Quonnipaug from the north end of the lake. The area in the foreground has been partially filled in and is property of the water company. The current boat launch is behind the hill on the far left. At two miles in length and one-half to one-quarter mile in width, this is one of the largest natural lakes in Connecticut, although its size has been increased several times by raising the dam at the southern end to increase the water flow to the town mill.

A narrow dirt road winds through farmland, with cows peacefully grazing in a pasture. Summer visitors from the growing cities in Connecticut prized these pastoral scenes. (Redfield B. West, c. 1895.)

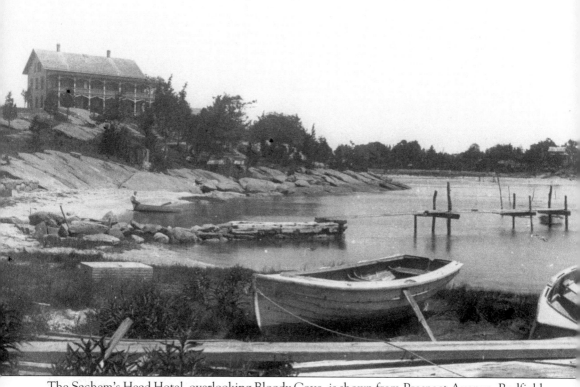

The Sachem's Head Hotel, overlooking Bloody Cove, is shown from Prospect Avenue. Redfield B. West, who lived on Fair Street, spent several summers here. The original Sachem's Head Hotel burned in 1865; John Barker built this much smaller version in 1878. At the time this photograph was taken, the hotel was known as Barker's Sachem House. It was later owned by Albert A. Sperry, brother-in-law of John Barker. (Redfield B. West, c. 1895.)

Five

SUMMER VISITORS

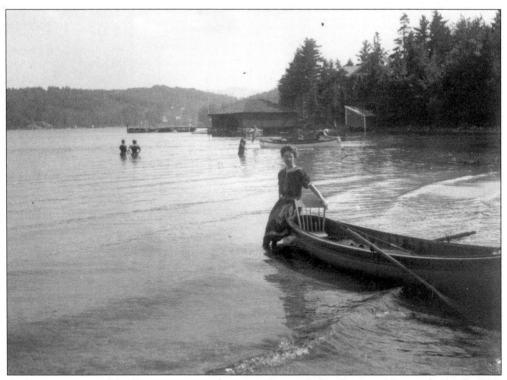

Both canoeing and bathing were popular activities at Lake Quonnipaug in the early 20th century. (Oliver B. Husted, *c.* 1909.)

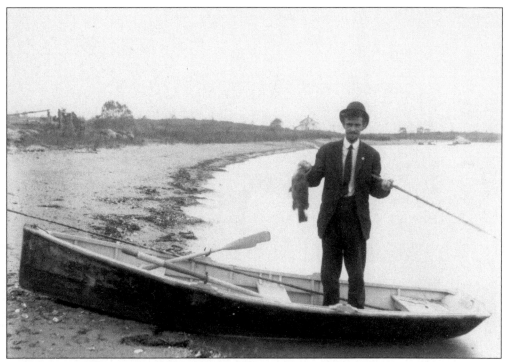

Edward Husted Jr., brother of photographer Oliver B. Husted, displays his catch of the day—blackfish for dinner. The location is Sachem's Head just east of Vineyard Point, with a view of the Daniel Brown Leete House, c. 1905.

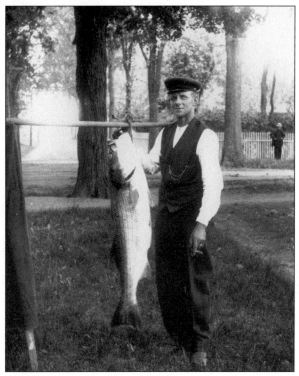

The Hill family made a living from the water. Reuben Hill (1876–1962) is justly proud of this large fish, perhaps a striped bass. Hill owned seven fish markets in Guilford at various times and sailed, rented, and built boats. The increasing number of summer residents meant more work for the Hill family. (Oliver B. Husted, c. 1905.)

In a scene still common today, this young man is gathering clams, either for the evening meal or to sell to summer residents. The first laws protecting oysters and clams in Guilford were passed in 1775. In 1879, it was voted that all shores should be free to inhabitants to gather long clams.

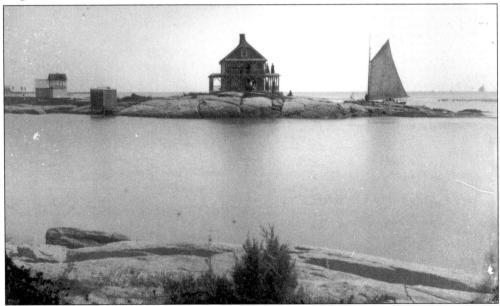

The Burwell Carter cottage, at 31 Loyal Ledge in Sachem's Head, was built in 1885 and was viewed as an ideal summer place. The *Shore Line Times* reported, "Probably no cottage on the Head is better designed for conveniences and enjoyment than Mr. Carter's cottage. It is built upon solid rock." Carter was a brass founder from Plainville. The cottage was razed in 1910 and replaced by a grander one built by Robert Mitchell. (Redfield B. West, c. 1895.)

This young woman is crabbing near Leetes Island *c.* 1898. This is still the most popular crabbing area in Guilford.

Appearing rather overdressed for the activity, Edward Husted Jr. is clamming at the mouth of Vineyard Creek at Vineyard Point. (Oliver B. Husted, *c.* 1905.)

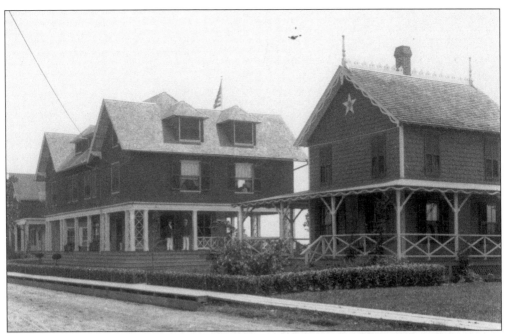

The large cottage shown in the center belonged to Howard C. Noble, manufacturer of Anchor brand hardware in New Britain. The cottage was built in 1902 on Prospect Avenue at Sachem's Head and was known as the Anchorage. Noble's intention was to remove the old, plain cottages and develop a summer showplace. The small cottage on the right was known as Star Cottage, for obvious reasons. (Henry S. Davis, c. 1912.)

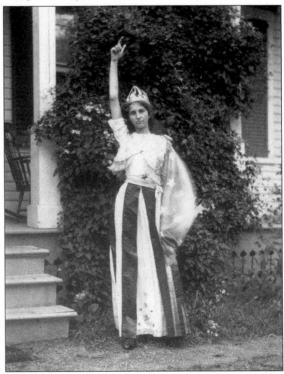

Amateur theatricals were popular with the young people. Perhaps this fair Liberty was posing for a Fourth of July tableau. (Oliver B. Husted, c. 1905.)

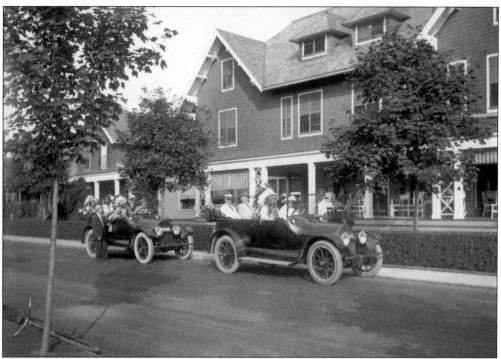

Buffalo Bill Cody and five Sioux Indian chiefs arrive at Howard C. Noble's cottage on July 16, 1916. They had motored out from New Haven, where they were to perform with Buffalo Bill's Wild West Show the next day. (Henry S. Davis, 1916.)

According to the *Shoreline Times* of July 20, 1916, "Indians go swimming while palefaces chat on the veranda of other days." (Henry S. Davis, 1916.)

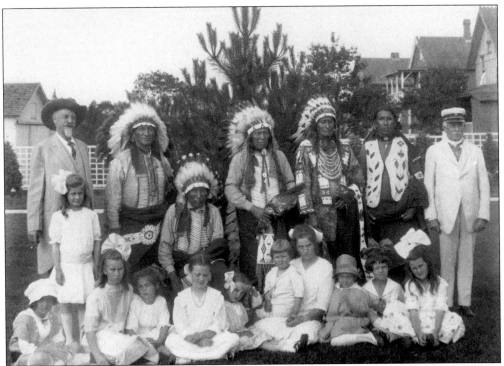

Buffalo Bill Cody and five Sioux Indian chiefs pose with Howard C. Noble and Sachem's Head children. The chiefs are Black Fox, Iron Cloud, Flying Hawk, Spotted Horse, and Iron Boy. (Henry S. Davis, 1916.)

Young people often acted out the stories of the day, with life on the frontier always a popular topic. (Oliver B. Husted, c. 1905.)

Not all summer visitors stayed at the shore. The Four Elms, converted from a house built for Wyllys Eliot in 1763, was a convenient tourist location in downtown Guilford. (Oliver B. Husted, *c*. 1905.)

William L. Roberts and an unidentified woman relax on the porch of the Roberts boardinghouse at 620 Colonial Road. The boardinghouse was a popular destination for those who wanted to spend the summer at the shore but did not have a cottage. It closed in 1900, after the death of William Roberts's aunt Josephine Roberts, who ran the boardinghouse. Howard C. Noble bought the property in 1915 and razed the house because it interfered with his sunset view. (Oliver B. Husted, *c*. 1909.)

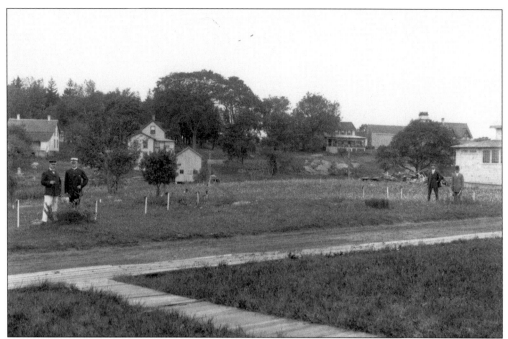

Most of the cottages at Sachem's Head were still new when Howard C. Noble staked out his driveway on Prospect Avenue in 1901. This was part of Noble's plan to enhance Sachem's Head and his own estate. Several of the smaller cottages were moved to make way for his plans. (Oliver B. Husted.)

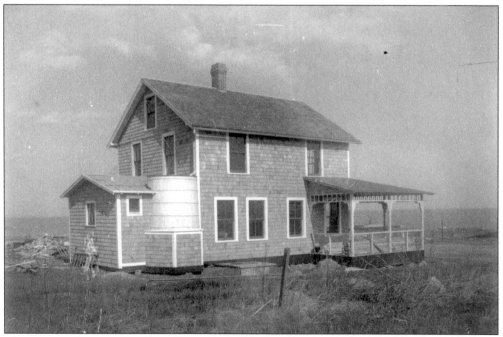

This Vineyard Point cottage is typical of the smaller cottages in the neighborhood. Note the cistern to collect rainwater. Since the cottage was built on stone, there was no way to have a well. A dry summer meant no fresh water. (Oliver B. Husted, c. 1905.)

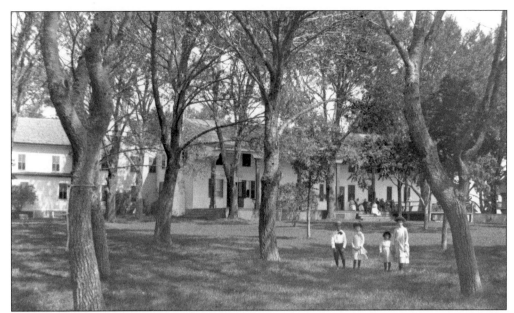

Families are shown enjoying the summer at the Guilford Point House, owned by James and Lucy Hunt, parents of photographer Harriette Hunt Bryan. There had been a hotel on this site since 1797, and the Hunt family enlarged an earlier structure in 1855. Much of the hotel shown here burned in 1897. Guests were lured by the attractions of seafood, sea bathing, and sea air. (Harriette Hunt Bryant, c. 1885.)

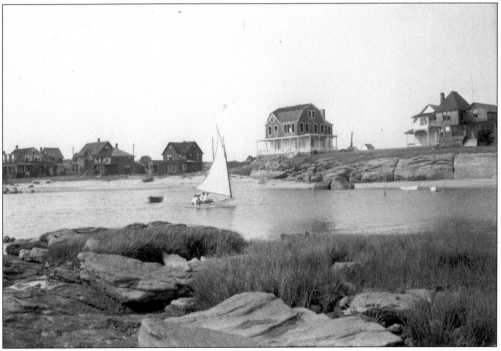

Four young people are shown sailing off Mulberry Point beach. The rocky shore, although an improbable place for housing, was popular for its views. Note the variety among the cottages. (Henry S. Davis, c. 1915.)

Six
MARITIME MATTERS

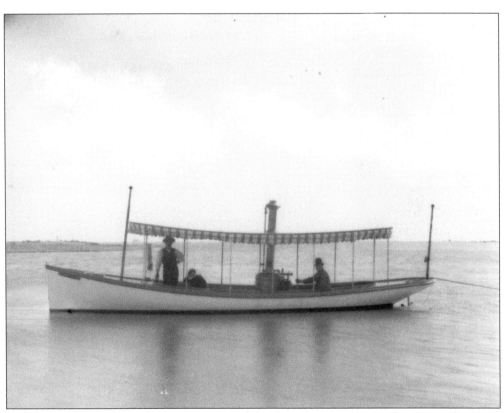

Making excursions by sail, steam, and naphtha launches was a popular form of summer entertainment. This is probably a steam launch cruising near the mouth of the West River. (Redfield B. West, c. 1895.)

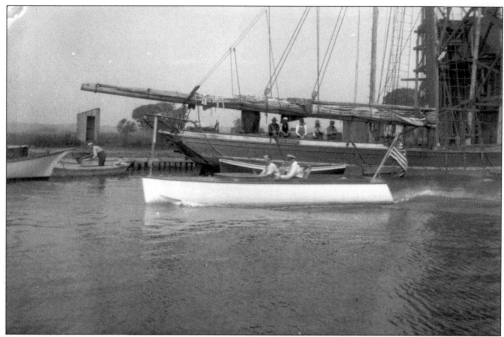

Two men in a motor launch pass by the stern of the *General Torbert* at the Sluice Basin. The *General Torbert* appears to be unloading coal at the coal pocket that once stood at 505 Whitfield Street. (Henry S. Davis, *c.* 1915.)

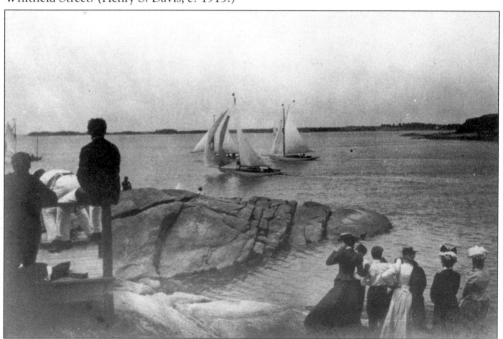

Sailboat racing was a popular summer sport in Guilford among the summer residents. During the 1880s, Barker's Sachem Head Hotel sponsored races. After the founding of the Sachem's Head Yacht Club in 1897, races were held almost every week during the summer season. This image dates from *c.* 1899.

Fishing, crabbing, and lobstering provided a living for many Guilford residents. In the foreground are lobster traps and skiffs. The summer residents were good customers of the local lobstermen. This photograph of the Newhall cottage (now 1 Falcon Road) was taken from the northern shore of Vineyard Point, across Newhall Bay. (Oliver B. Husted, c. 1905.)

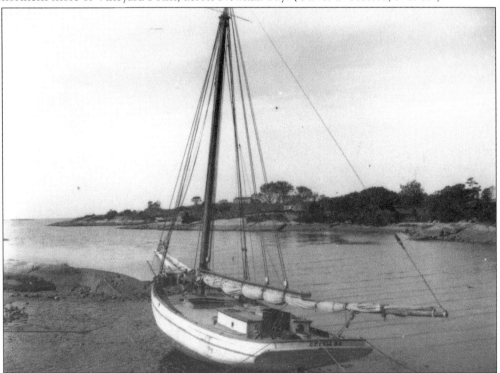

William Roberts used *Cyrus Pell* for freighting local produce to New York and Rhode Island and perhaps fish to Branford. He gave his occupation as sailor and fisherman. This photograph was taken at low tide in the mud flats at Roberts Point, Sachem's Head, near 600 Colonial Road. (Oliver B. Husted, c. 1909.)

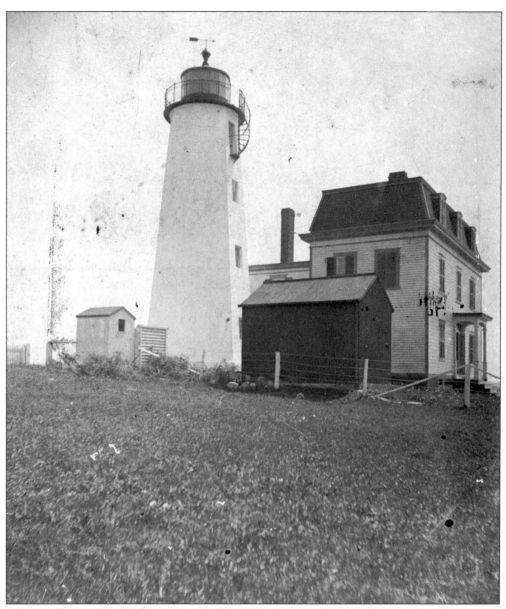

The Faulkner's Island light station and the light keeper's house were erected in 1802. The tower is about 50 feet high and is octagonal, typical of lighthouses built before 1830. The lighthouse is on a small island about three-and-a-half miles off Mulberry Point. The outbuildings housed workshops, chicken coops, a tool house, and siren and engine rooms. Erosion has brought the lighthouse perilously close to the edge of the island. Restoration efforts are now under way to reverse the erosion. This image dates from c. 1910.

In this *c.* 1885 photograph, Capt. Oliver N. Brooks and his grandson Oliver Brooks Husted entertain an unidentified photographer and dog with a violin recital. Brooks was the Faulkner's Island lighthouse keeper for 31 years.

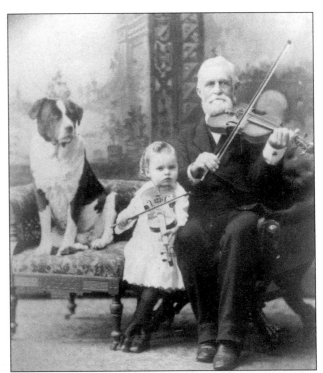

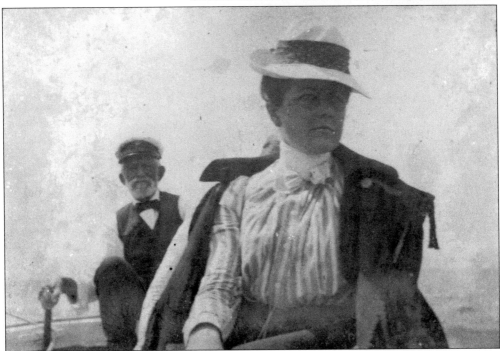

Capt. Oliver N. Brooks is shown at the tiller of his boat with an unidentified passenger. Brooks won a medal of honor for single-handedly rescuing the seven-man crew of the schooner *Moses V. Webb*, which was wrecked on the rocks of Faulkner's Island in 1859 during one of the worst storms Long Island Sound had seen. (Oliver Brooks Husted, *c.* 1909.)

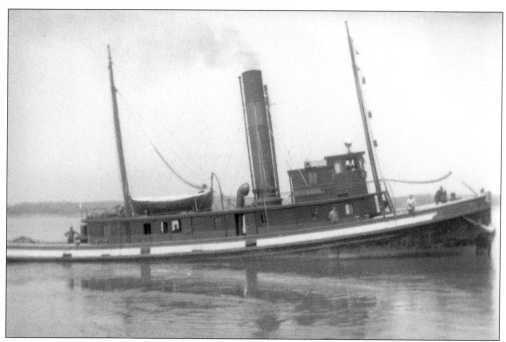

The steam tug *Sea King*, captained by Harvey Bragdon, originally belonged to the Hughes Brothers & Bangs Quarry and was used to tow barges full of granite. In this *c.* 1905 picture, the *Sea King* is under way, probably off Uncas Point in Sachem's Head. At that time, the Federal Contracting Company owned the quarry. (Oliver B. Husted.)

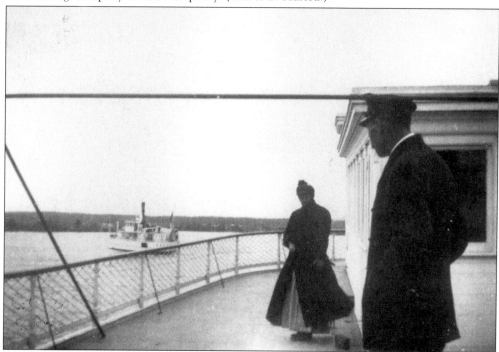

This large vessel is heading into Guilford Harbor. Off the port bow, a tugboat is towing logs. (Oliver B. Husted, *c.* 1905.)

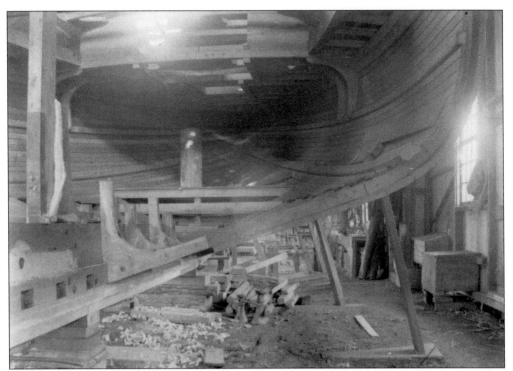

This photograph shows a large vessel under construction, possibly at Brown's Boatyard. At one time Guilford had seven boatyards on both the East and West Rivers. (Oliver B. Husted, c. 1905.)

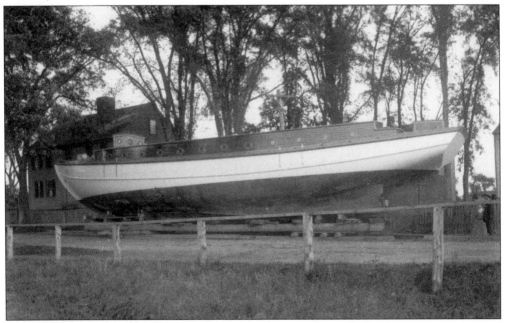

Boat building was once a more common part-time occupation. The boat was constructed alongside someone's house and was then dragged by horse or oxen down the street to be launched, in this case in the West River. (Oliver B. Husted, c. 1910.)

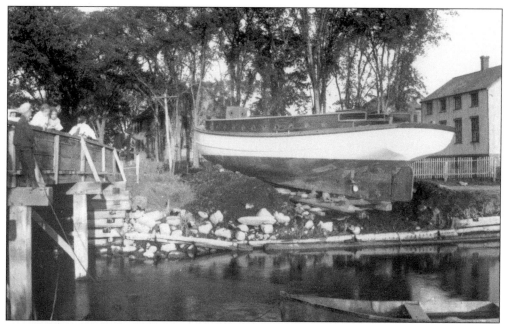

The 60-foot, twin-screw boat *Gray Dawn* is being launched at the edge of the West River at Jones Bridge. William Fowler built the *Gray Dawn* (representative of the power craft being built as pleasure boats) for Dr. Hurst of Washington, D.C. (Oliver B. Husted, 1906.)

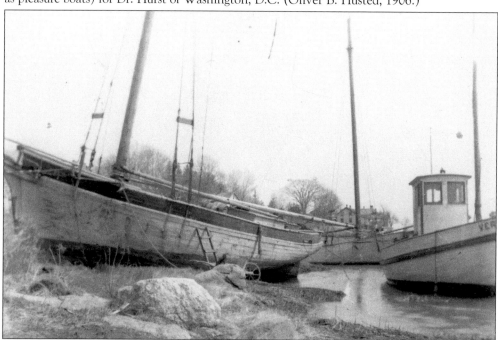

Two of the vessels belonging to the Roberts family are shown up on land. The sloop *Fred R.* belonged to Orlistus Roberts, who used it for freighting produce and fish. *Vera* belonged to his son William L. Roberts and was also used for freighting. Orlistus Roberts was recognized as a good sailor even though he lacked the administrative ability needed to run the family boardinghouse. (Oliver B. Husted, *c.* 1909.)

Seven

COMMERCE AND INDUSTRY

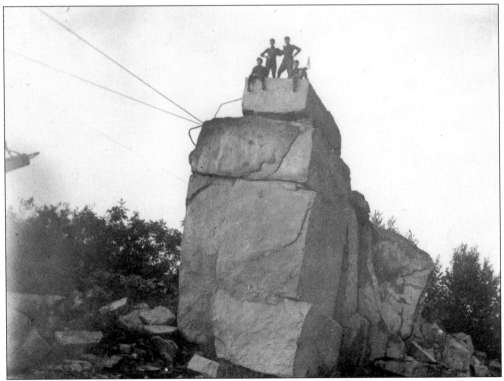

Workmen at Hanna's Quarry pose c. 1915. This formation, known as a derrick anchor, can still be seen while hiking the White Trail in West Woods. (Daniel Sheehan.)

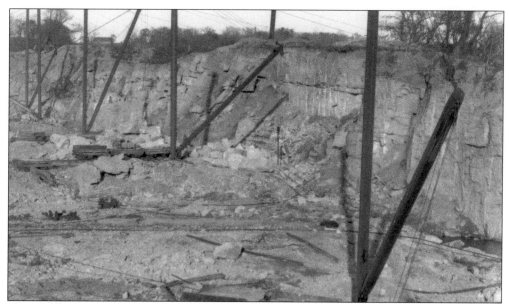

The Hughes Brothers & Bangs Quarry was the only quarry in Sachem's Head. This c. 1910 image shows derricks, large sheets of granite, and the tracks that converged at the docks, where the granite was loaded onto barges. At that time, the quarry was owned by the Breakwater Company. The Guilford granite was used in breakwaters at Point Judith (Rhode Island), Saybrook, and New Haven. (Henry S. Davis.)

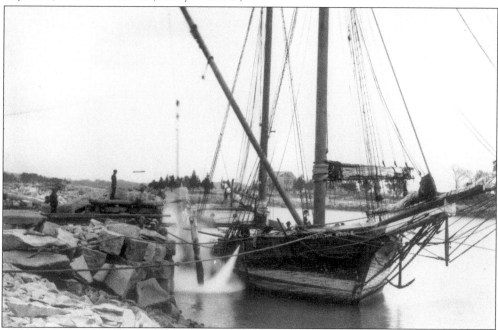

Large blocks of granite are being loaded onto the schooner *American Eagle*. Granite from Beattie's Quarry was used in the Brooklyn Bridge, Grand Central Station, the New York & Harlem Railroad, and the base of the Statue of Liberty. The quarry opened in 1869 and closed before World War I. The *American Eagle* was sold to a Boston company and was later scuttled. (Henry S. Davis, c. 1910.)

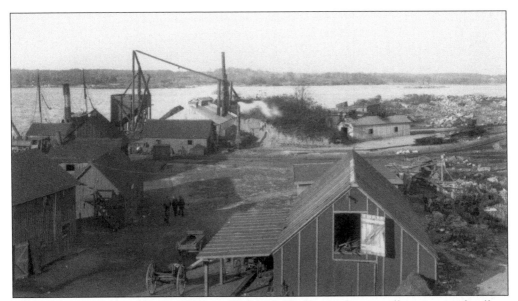

The quarry operation at Uncas Point on Sachem's Head was also a small seaport, with offices and docks where the granite was loaded. This photograph was taken during the ownership of the Breakwater Company. (Oliver B. Husted, *c.* 1909.)

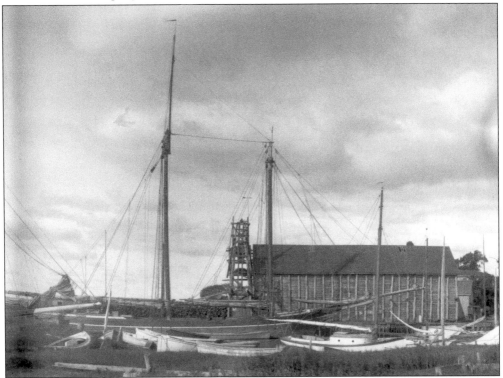

Coal was essential for heat *c.* the beginning of the 20th century. Much of the coal brought to Guilford between 1895 and 1910 arrived by schooner and was stored in the coal pocket. This coal pocket was used for about 10 years and was removed in 1923. By then it was no longer required because the coal was coming in by railroad. (Henry S. Davis, *c.* 1915.)

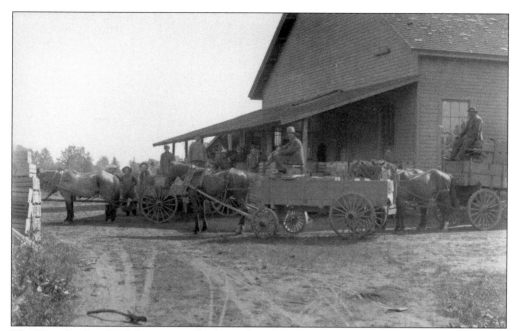

The Knowles-Lombard Company, which employed over 100 people during the busy season, was the largest of Guilford's canneries. Puritan brand hand-packed tomatoes, most of which were grown in town, were the featured product. More than 450,000 cans were shipped each year, primarily to New York and Boston. (Henry S. Davis, c. 1915.)

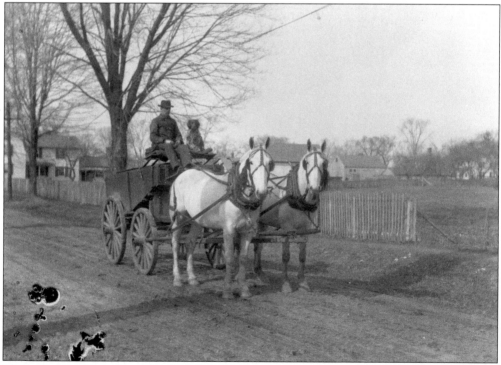

The coal was delivered to individuals by coal wagons. Accompanied by his dog, Frank Blatchley is shown here driving his coal wagon, probably on River Street. (Henry S. Davis, c. 1915.)

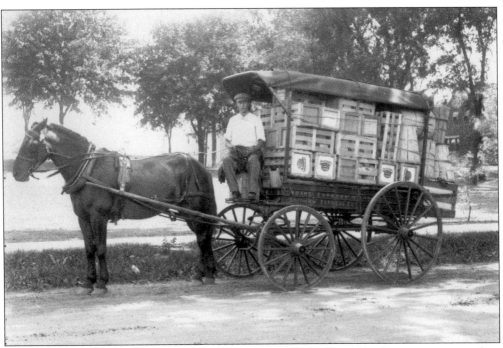

The Adams Express Company carried freight to and from the railroad station, serving shop owners and individuals. (Oliver B. Husted, *c.* 1909.)

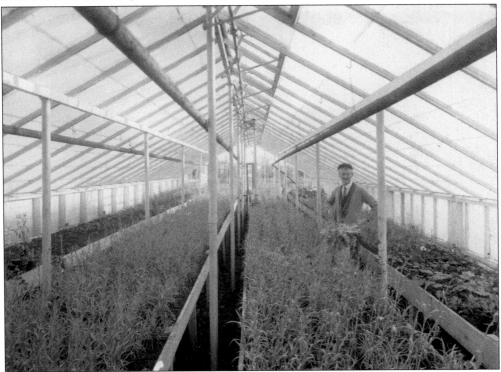

Bradford Latham is shown here working in his greenhouse on Graves Avenue. (Oliver B. Husted, *c.* 1906.)

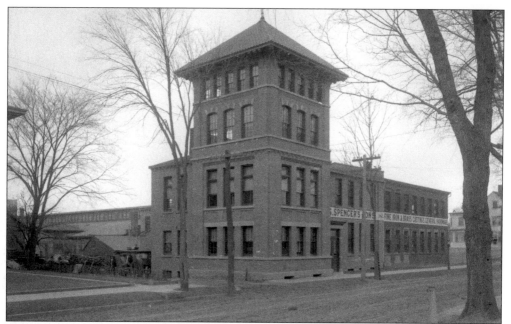

The I.S. Spencer & Sons Foundry occupied a preeminent place in Guilford's industrial community for over a century. Founded by Isaac Stow Spencer and his son Christopher Spencer, the company was operated by three generations of Spencers. (Henry S. Davis, c. 1915.)

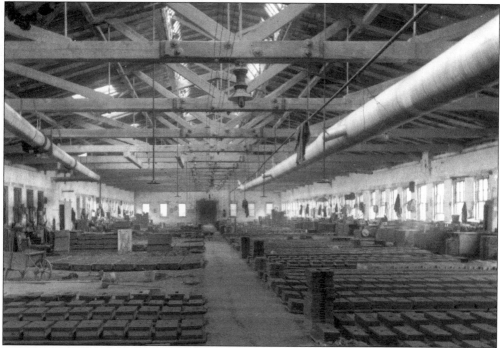

The fine iron castings for which the Spencer foundry was famous are shown here in the molding room. The company was also well known for its line of tea, counter, and Universal family scales. (Henry S. Davis, c. 1915.)

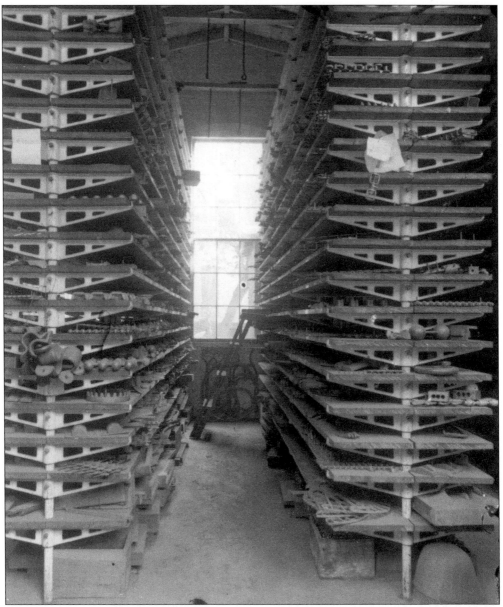

Casting at the I.S. Spencer & Sons Foundry was performed using these cores, stored on the racks. Green sand or another form of sand was put in a box and leveled. The core was pushed into the sand to make an impression. Molten iron was poured in the mold, and the casting was made. (Henry S. Davis, c. 1915.)

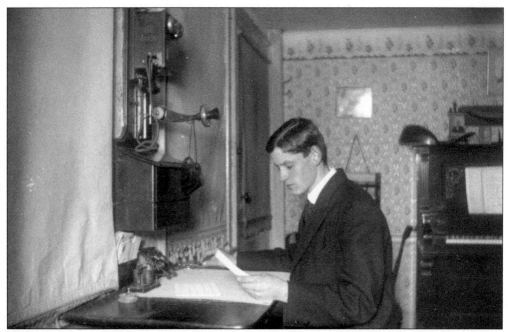

Edward G. Husted Jr. served as telegraph operator for several years in the early 20th century in Guilford, which received telegraph service in the 1850s. Guilford was one of the first towns on the shoreline to have this service. (Oliver B. Husted, c. 1909.)

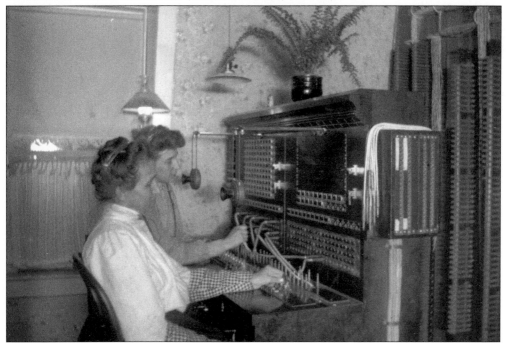

Some 350 customers were served by this telephone exchange, located in the home of Annie Dudley. About 2,000 calls were handled each day during the summer, and 1,500 were taken each day during the winter. In this photograph, Minnie Hull Dudley and Mrs. Graves are putting through calls. (Oliver B. Husted, c. 1909.)

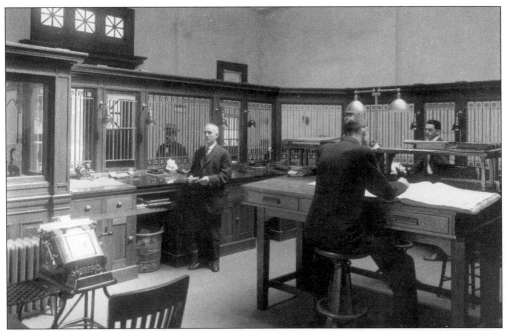

The original interior of the Guilford Trust Company Bank is shown here *c.* 1915. Until 1951, the Guilford Trust Company and Guilford Savings Bank shared this room and employees, who sorted out deposits at the end of the day. The interior was updated in 1957, after being taken over by a New Haven bank, and it is now part of Page Hardware Store. (Henry S. Davis.)

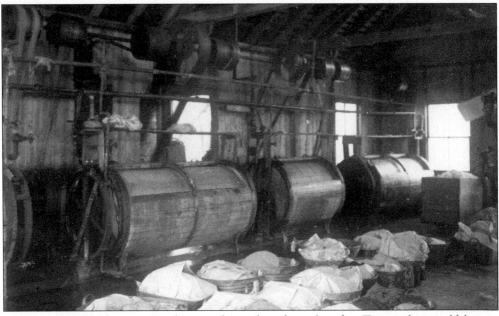

Walker's Wet Wash represented a step forward in doing laundry. Ten washes could be put in each of the large machines. After the washing operation, the clothes were placed in an extractor to remove most of the water. The clothes were then returned to a basket and delivered wet to the customer. The entire process took about an hour and a half. (Henry S. Davis, *c.* 1920.)

This image of the attic of the Landon & Davis warehouse provides a rare behind-the-scenes look at an early-20th-century retail business. (Oliver B. Husted, c. 1909.)

The Shore Line Times began publishing a weekly newspaper in 1878 and moved to Guilford in 1895. Charles Scholey, the owner in 1915, is shown here in the offices the Kimberly Building, at 63 Whitfield Street. (Henry S. Davis, c. 1915.)

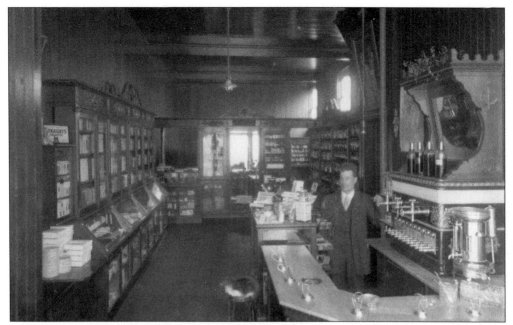

The interior of the drugstore in the Kimberly Building, at 63 Whitfield Street, is shown c. 1905. The drugstore, known as one of the finest on the shoreline, was operated by George M. Ladd between 1903 and 1906 and subsequently by A.C. Roby and Frank Douden. (Oliver B. Husted.)

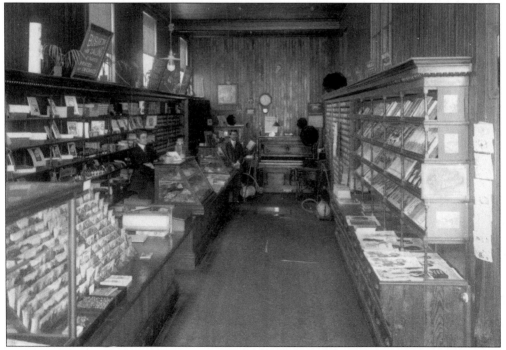

Dudley and Beckwith, stationers, occupied the other half of the front of the Kimberly Building. Still in operation today, the business is located in the Brick Block on Water Street. (Henry S. Davis, c. 1912.)

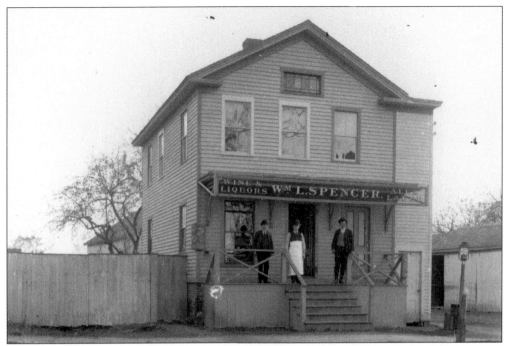

William L. Spencer's wine and liquor store on Water Street, also known as "Bill Spencer's Saloon," was one of only a few places residents could buy liquor in town. (Henry S. Davis, *c.* 1915.)

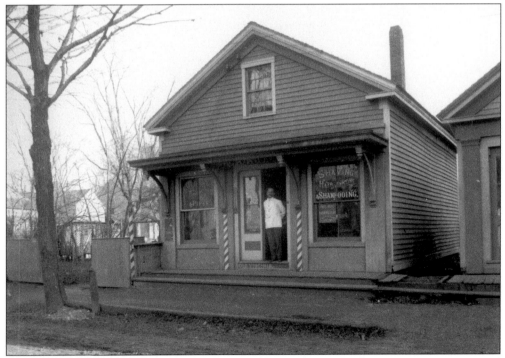

Adolph G. Sommers, standing in the driveway, operated his barbershop on Water Street until 1920. (Oliver B. Husted, *c.* 1909.)

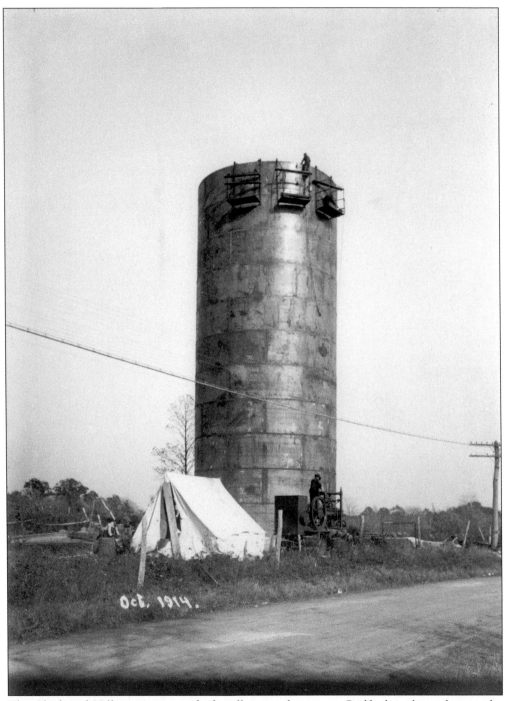

Oct. 1914.

The Clapboard Hill water tower, which still serves downtown Guilford, is shown here under construction in October 1914. (Henry S. Davis.)

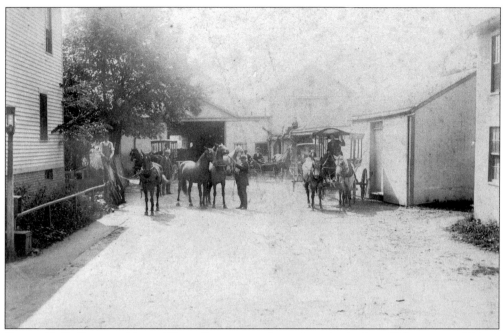

George Rolf's livery stable on Water Street was a busy place in the late 19th century. This c. 1890 photograph seems to show the available livery and employees.

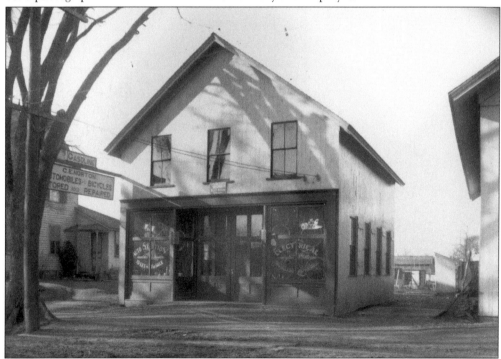

This is Clarence Norton's first shop at 23 Water Street. Norton opened it as a bicycle-repair shop but soon expanded into automobile repairs and the sale of gasoline. The business prospered sufficiently to require construction of his second garage on Boston Street. (Oliver B. Husted, c. 1909.)

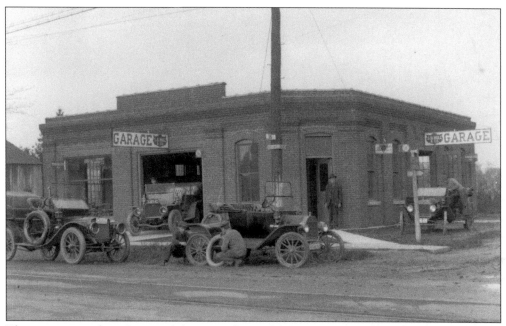

The growing number of automobiles created a need for maintenance facilities. This busy garage was built in 1913 by George Edwin Hull and his sons, Herbert and Sherman. It was located down the street from the site of Clarence Norton's second garage. As this was then the Boston Post Road, there was ample business for both garages. (Henry S. Davis, c. 1915.)

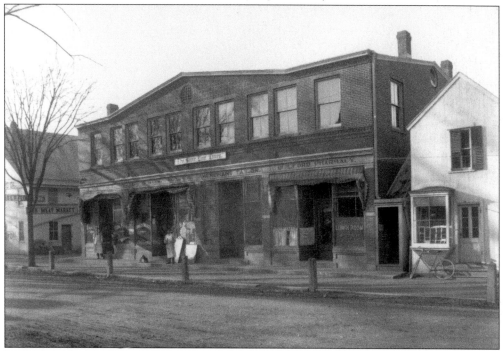

The Brick Block, Guilford's response to modern commercial architecture, housed J.E. Norton & Sons Grocery, the Guilford Pharmacy, and the Shore Line Times. (Oliver B. Husted, c. 1909.)

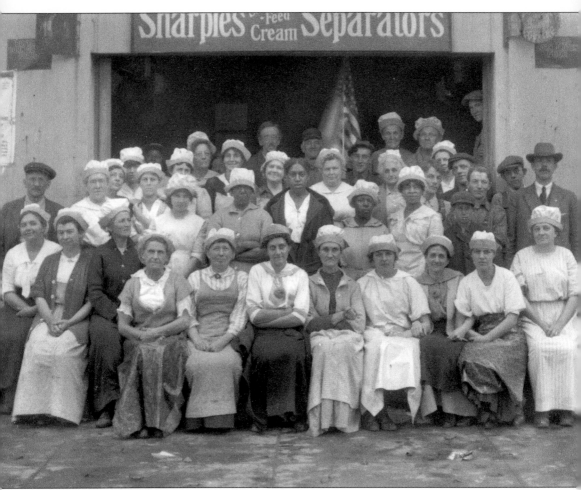

Workers of the Sachem's Head Canning Company, located on Water Street, take a break for this group photograph. The company was started in 1881, with Alfred P. Sloan of New Haven as president and Darwin N. Benton as treasurer. The business was primarily the canning of tomatoes and pumpkins, which were either bought from Guilford farmers or grown in company fields. (Henry S. Davis, c. 1915.)

Eight
TRANSPORTATION

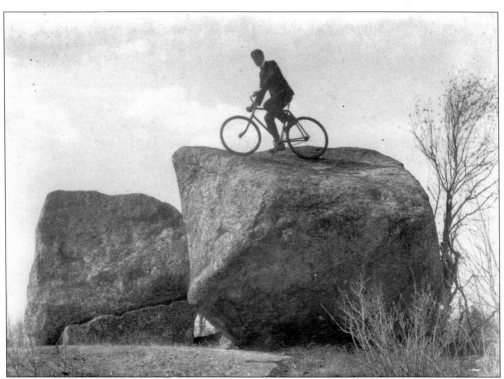

Earle Jacobs poses near his home. The location is Hanna's Rocks at Hanna's Quarry, now part of West Woods. Not even today's mountain bikes could traverse this large remnant of the Ice Age. (Daniel Sheehan, c. 1915.)

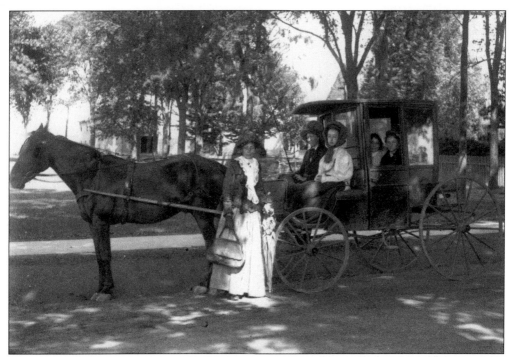

The horse and carriage was still the most prevalent form of vehicle travel in 1905. (Oliver B. Husted.)

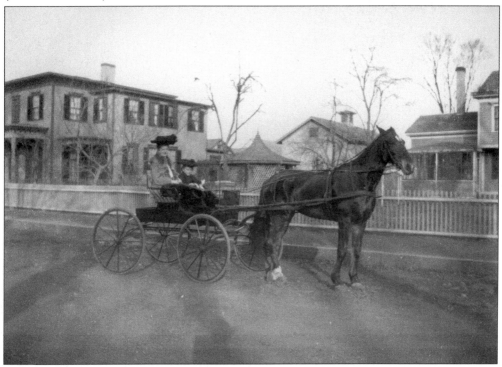

The buggy was considered a safer means of travel for women and children. This one pauses on its way down Fair Street. (Oliver B. Husted, *c.* 1905.)

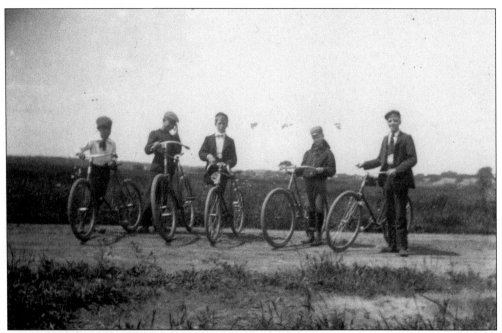

The bicycle was the favorite mode of transportation for the young. These young men are preparing for a race. (Oliver B. Husted, *c*. 1905.)

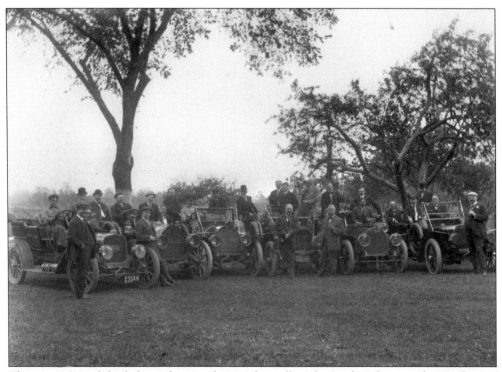

The new automobiles belonged most often to the well to do. In this photograph, members of the Union League Club of New Haven have motored out for a party at Rollwood, the country home of Connecticut's lieutenant governor, Rollin Woodruff. (Oliver B. Husted, *c*. 1906.)

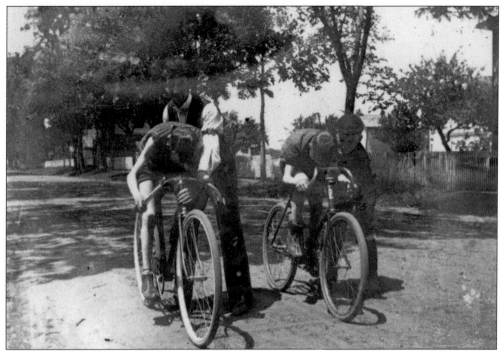

The Gay Nineties saw a regular schedule of bicycle races around the Guilford Green and on other courses around town. Claude Harrison was the most frequent champion.

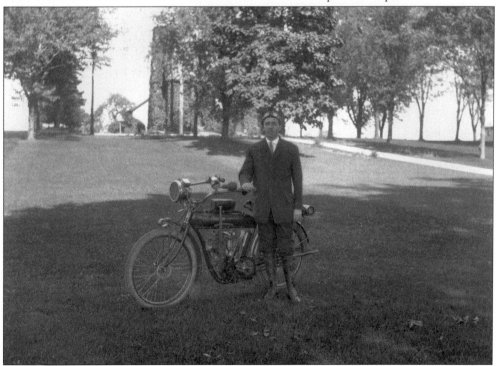

Dennis Bacon, posing here on the grounds of the Henry Whitfield House, owned the first "motor bicycle" in town. (Oliver B. Husted, *c.* 1905.)

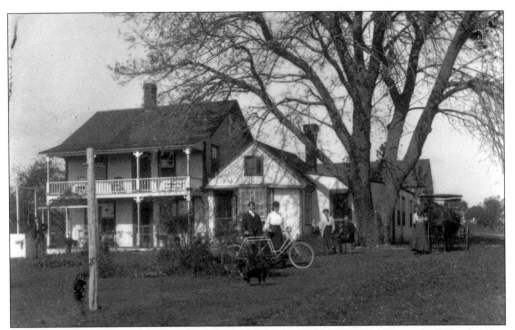

Everyone in the family, including the horse and dog, is included in this Green Hill Road scene. The buggy, although it was nearly outmoded by 1915, represented a level of prosperity that could get the family to town or church in comfort. The tandem bicycle was an inexpensive way for a courting couple to travel. (Henry S. Davis, *c.* 1915.)

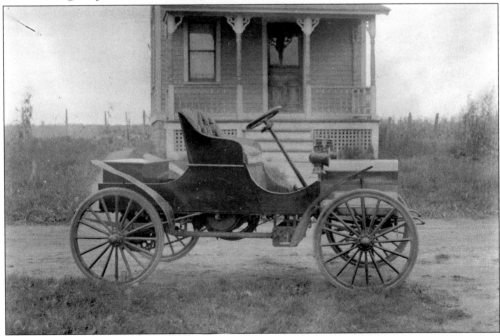

Shown here are the status symbols of a new age: a summer cottage and an automobile. While both of these are on a less-than-opulent scale, they indicate middle-class prosperity. The automobile pictured here is an early-1900s, chain-driven model. (Oliver B. Husted, *c.* 1905.)

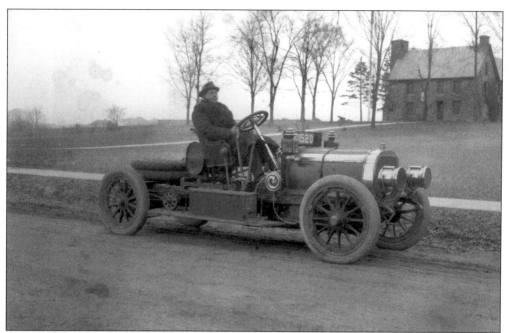

Clarence Norton, owner of Norton's Garage, is shown here testing Mr. Haynes's car. Norton began his career repairing bicycles. (Oliver B. Husted, *c.* 1905.)

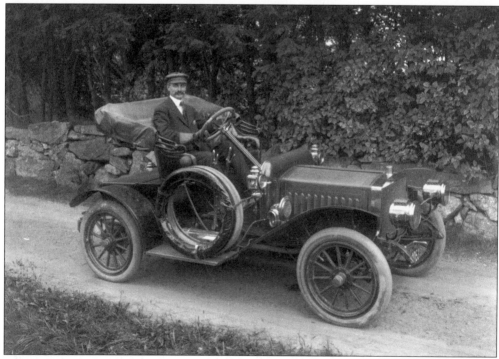

Doctors often owned automobiles, as they benefited from the increased speed available when calling on their patients. Dr. J.H. Evans, who lived on Whitfield Street, was a familiar sight around town. Unlike some doctors who required a chauffeur, Evans drove his own vehicle. (Oliver B. Husted, *c.* 1905.)

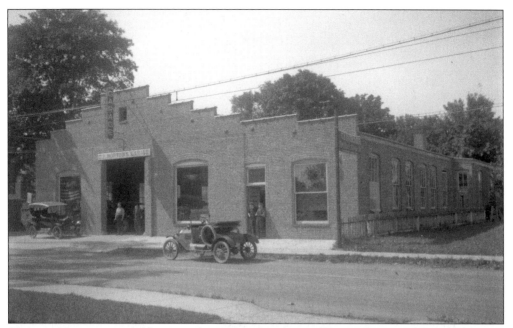

Clarence Norton operated his second garage at the corner of Boston Street and Graves Avenue. Early automobiles broke down frequently, requiring frequent visits to the garage. Shelton W. Dudley Sr., collector of most of the photographs in this book, worked at Norton's Garage, where he specialized in building and repairing starters and other electrical equipment. (Henry S. Davis, c. 1915.)

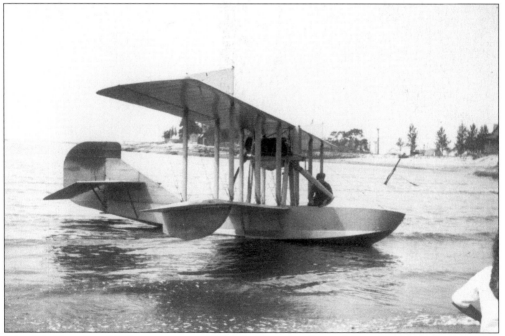

John M. Tweed, a Madison summer resident and a grandson of "Boss" Tweed of New York, lands his small seaplane at Bloody Cove in 1913. An airplane at this time was a rare sight indeed.

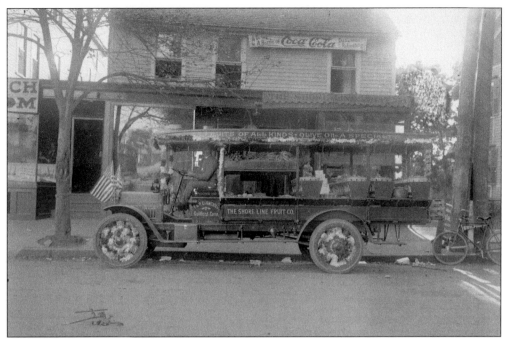

Horse-drawn delivery wagons were gradually replaced with trucks. The Shoreline Fruit Company, owned by Frank and Paul Cianciolo, sold fruit and vegetables in its store at 81 Whitfield Street and delivered produce purchased in New York to local stores. In this photograph, the company's Dodge truck appears to be decorated for the Fair Day parade. (Henry Davis, c. 1920.)

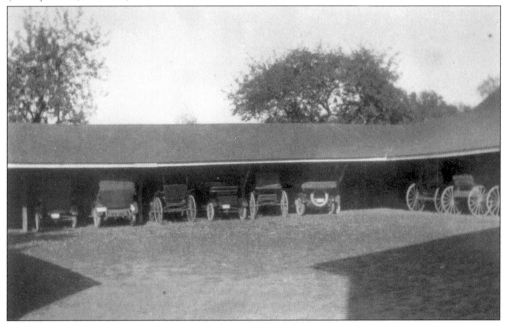

The sheds at the First Congregational Church, built to cover the horses and buggies of the churchgoers, housed more than buggies by the time this picture was taken c. 1915. (Henry S. Davis.)

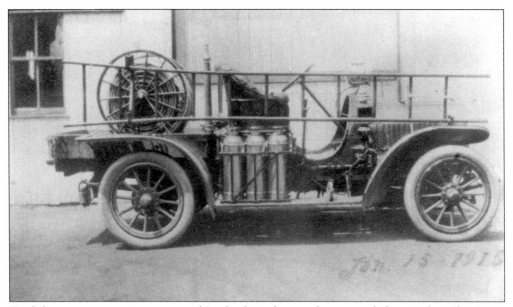

Firefighting capacity was increased with the advent of motorized fire trucks. This Pope chemical truck, shown here in Norton's Garage, was the first of its kind in Guilford. (Henry S. Davis, 1915.)

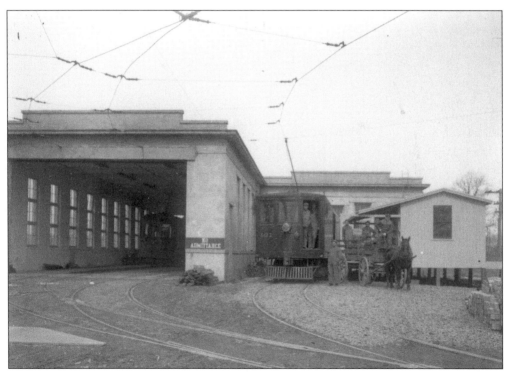

The trolley barn, built in 1910 of concrete blocks, served both the Shoreline Electric Railroad, which began service in 1910, and the trolley that went to North Branford. This sturdy building still stands on the corner of Water and River Streets. (Henry S. Davis, c. 1915.)

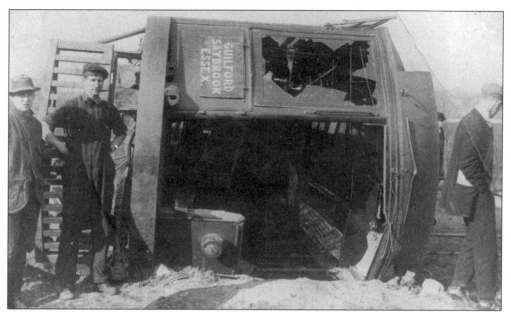

While the trolley was convenient and inexpensive, accidents could happen. This derailment occurred on May 4, 1912. (Oliver B. Husted, 1910.)

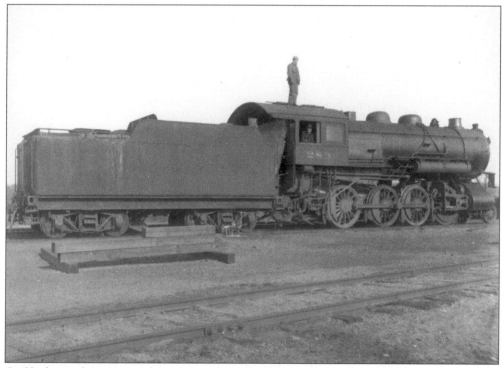

Guilford was fortunate to be on a main railway line. Coal-fired steam locomotives, both passenger and freight, made regular stops. The railroad had come to Guilford in 1852, making it a well-established institution by the early 20th century. (Henry S. Davis, c. 1915.)

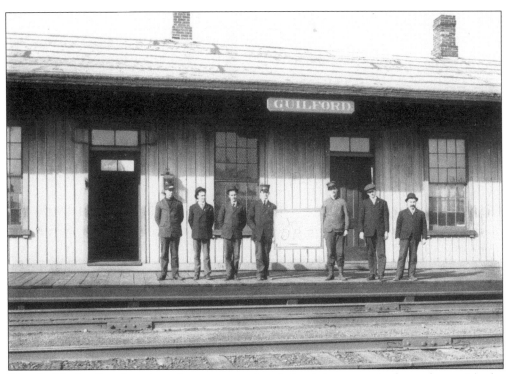

The Guilford railroad station, the transportation hub of the town, is shown here with the station workers. (Oliver B. Husted, *c.* 1905.)

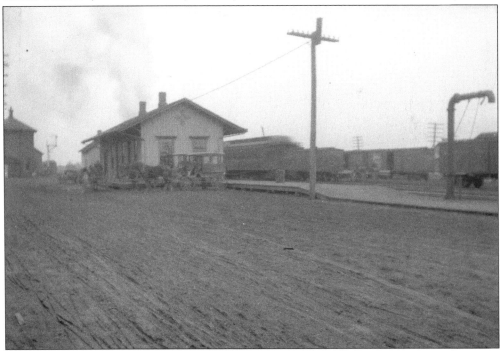

The main Guilford train station was built *c.* 1853, when passenger service was begun. The building was razed by Amtrak in the spring of 2000. (Oliver B. Husted, *c.* 1905.)

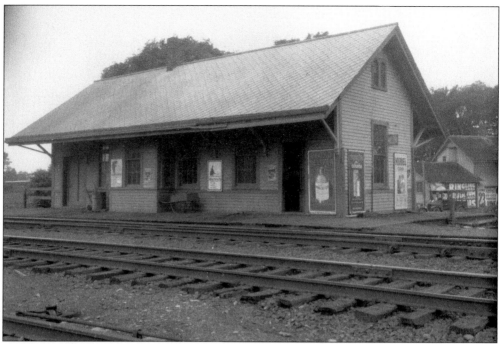

The East River train station served residents and businesses in the eastern section of town. Although it was only about a mile from the main station, there were enough businesses to keep the station open for many years. (Henry S. Davis, *c.* 1920–1930.)

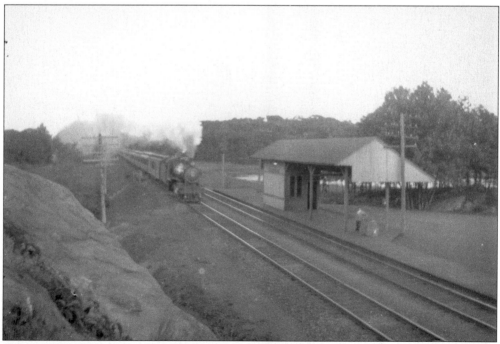

The Sachem's Head train station, located near where Leetes Island Road passes under the railroad, served both the year-round residents of Sachem's Head and the growing summer colony. (Oliver B. Husted, *c.* 1907.)

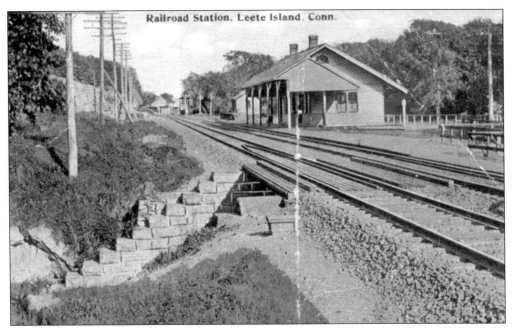

The Leetes Island train station, which was near Beattie's quarry and only a mile from the Sachem's Head station, served the quarry workers and the summer residents of Leetes Island. The building has been converted into a dwelling. (Oliver B. Husted, *c.* 1905.)

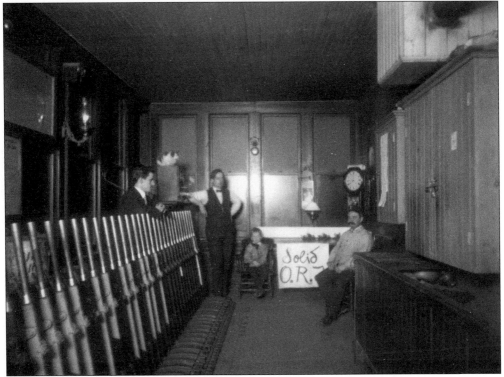

Shown in the tower of the Guilford railroad station with the switching equipment are workers Ed Husted, Wen Smith, and Bill Sennet and a unidentified boy. (Oliver B. Husted, *c.* 1905.)

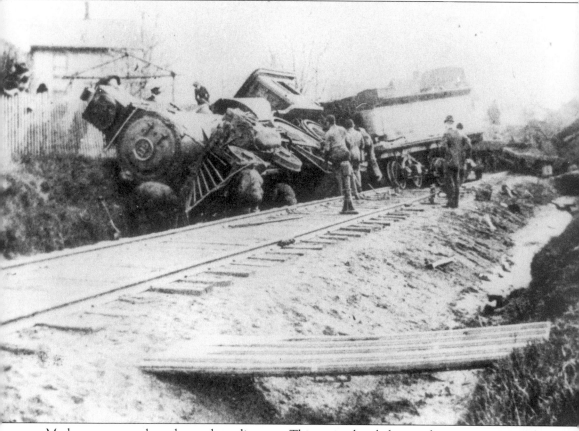

Modern transport brought modern disasters. This train derailed near the intersection with Whitfield Street *c.* 1890. At the time, there was only one track, so an accident of this magnitude would stop traffic for at least a day.

Nine
WORKING THE EARTH

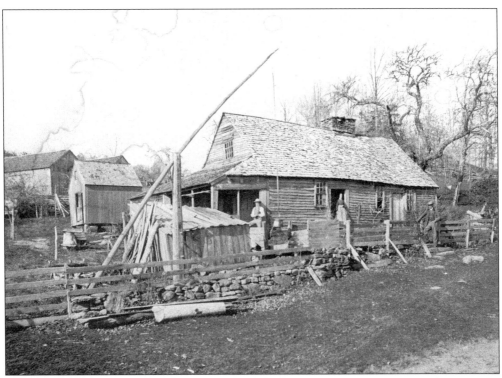

The Edward Loper farm was located on Durham Road in North Guilford. Edward Loper, also known as "the blind miller," kept a typical farm of the late 19th century. Note that the barns are in better repair than the house, in this c. 1880 image.

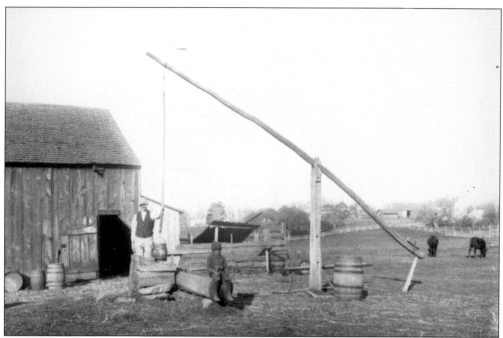

Stone's Cider Mill on River Street operated for well over a century. The well sweep shown in this photograph was a common sight in many yards. Note the counterweight on the right, which helped to raise the bucket once it was filled. (Oliver B. Husted, *c.* 1905.)

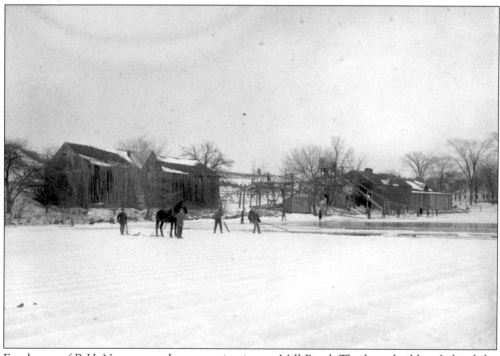

Employees of R.H. Norton are shown cutting ice on Mill Pond. The large building behind the men is the ice shed. Ice that was cut in the winter and stored in ice sheds was sold throughout the summer. (Henry Davis, *c.* 1915.)

Frederick H. Rolf owned one of several large greenhouses in town. He grew vegetable and flower seedlings, which were sold to farmers and other residents. (Henry S. Davis, *c.* 1920.)

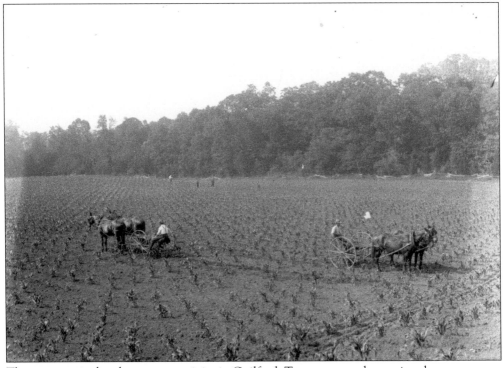

This was a typical early-summer activity in Guilford. Two teams are harrowing the young corn. (Henry S. Davis, *c.* 1915.)

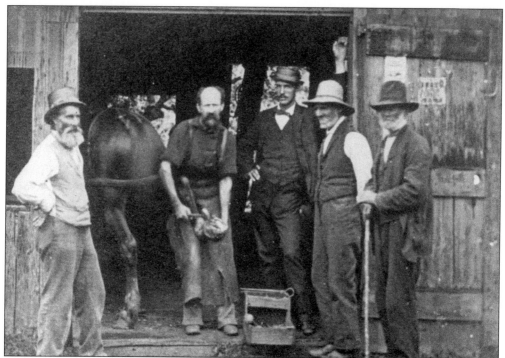

A horse is shoed at Harvey Leete's blacksmith shop on York Street (now the Boston Post Road, Route 1). (Charles D. Hubbard, *c.* 1910.)

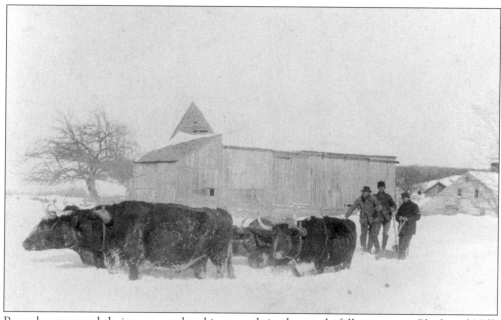

Parmelee men and their oxen are breaking a path in the newly fallen snow at Clapboard Hill. Before snowplows came into general use, snow was flattened to make a path for sleighs, using the oxen to break a path and a roller to smooth it. Given the unpaved and pothole-ridden roads, traveling was often at its best on a path of freshly rolled snow. (William A. Dudley, 1895.)

This house, which once stood at 223 Water Street, only two blocks from the downtown area, shows the agricultural character of the town in its most central areas. (Daniel Sheehan, c. 1907.)

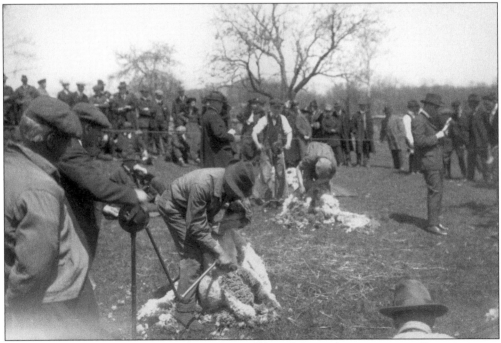

This sheepshearing event obviously attracted many interested spectators. William S. Leete, who was president of the Guilford Agricultural Society, owned the farm originally granted to William Leete, the first governor of Connecticut. (Henry S. Davis, 1915.)

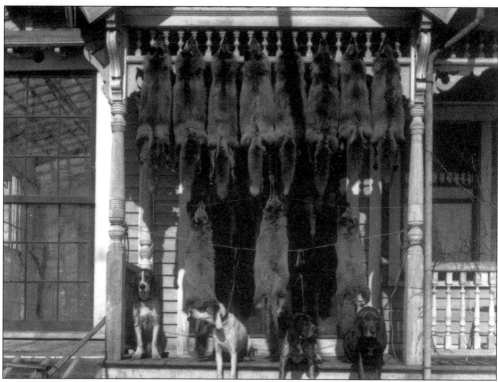

These contented hunting dogs rest after a good day's work. The fox in the henhouse was an ever present threat. (Redfield B. West, *c.* 1895.)

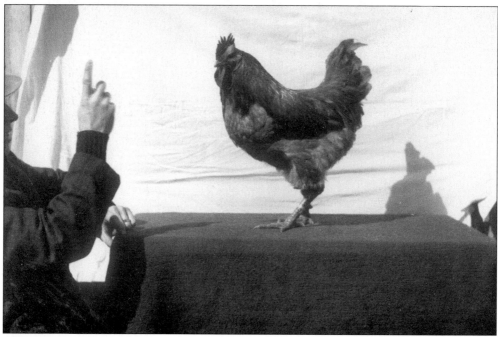

Chickens are not easy subjects for portraiture, as can be seen from the effort required to get this potential prizewinning rooster to stand still. (Henry S. Davis, *c.* 1920.)

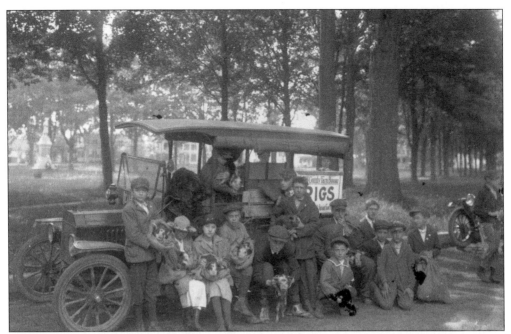

The youths of the town were encouraged by the New Haven Farm Bureau to raise pigs. These children are shown at the beginning of the project, on the southeast corner of the Guilford Green. (Henry S. Davis, *c.* 1920.)

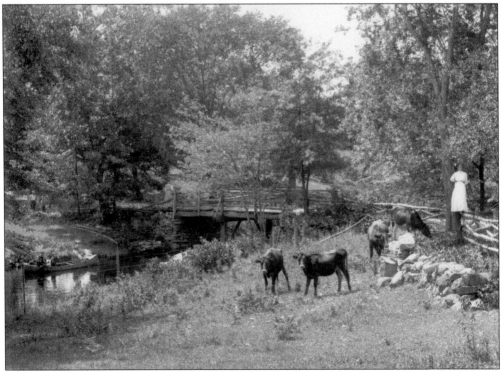

Oliver B. Husted captured this peaceful summer scene in 1905. The cows share the pasture near Foote's Bridge with several young people and a canoe.

These cattle belonging to Daniel Reeves Spencer enjoy a scenic view in Henry Spencer's "big lot" south of Prout Street at Pipe Bay in Indian Cove. (Henry S. Davis, c. 1915.)

E. Walter Leete points out cattle on his farm at Leetes Island. Leete repurchased land that had passed out of Leete ownership, a practice continued by his son William S. Leete. (Redfield B. West, c. 1895.)

Sheep were frequently raised on Guilford's rocky pastures, but their numbers had declined by c. 1910, when this picture was taken.

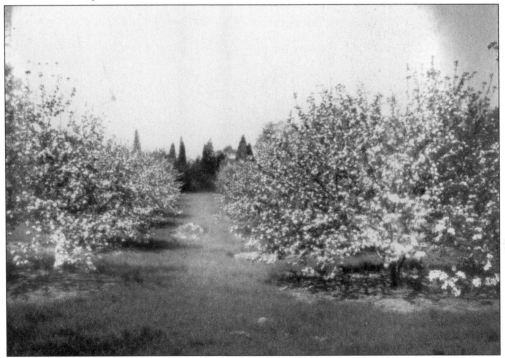

The automobile made the country farm stand economically viable. Bishop's Orchards, now one of Guilford's major agricultural enterprises as well as one of its major attractions, is shown here in its early years, with the apple trees in bloom. (Henry S. Davis, 1926.)

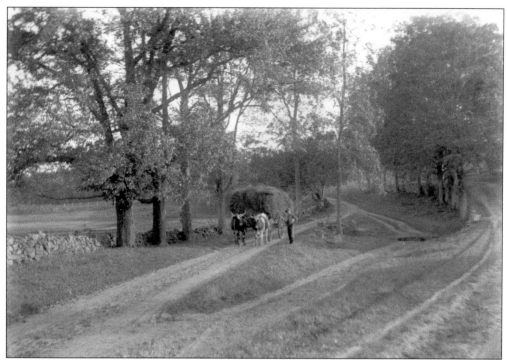

This hay wagon may be transporting salt hay from the marshes near Three Mile Course. Well into the 20th century, local farmers continued to use oxen for hauling and plowing. The fork to the right is the driveway to the Medad Stone tavern. (Henry S. Davis, *c.* 1915.)

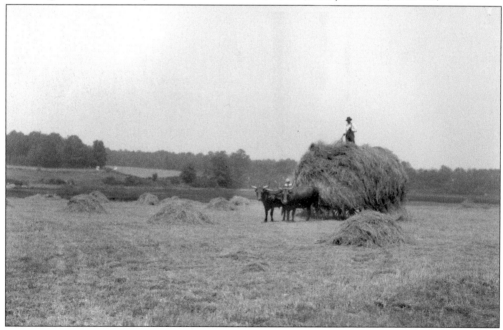

Make hay while the sun shines. In this case, the upland hay being harvested on the Daniel R. Spencer farm on Three Mile Course will be stored for winter use or exported to cities such as New York and New Haven. (Henry S. Davis, *c.* 1915.)

Ten
PRESERVATION EFFORTS
AND LOST
OPPORTUNITIES

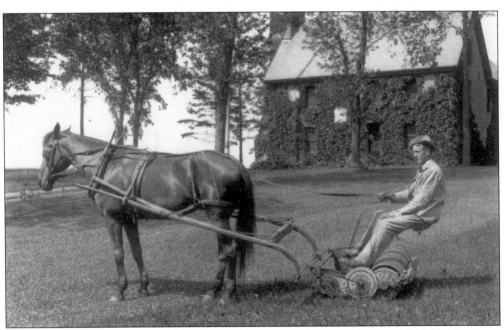

Modern technology is juxtaposed with the Henry Whitfield State Museum, the oldest house in Connecticut. This "one-horsepower" mower was much faster than a hand mower. (Oliver B. Husted, *c*. 1905.)

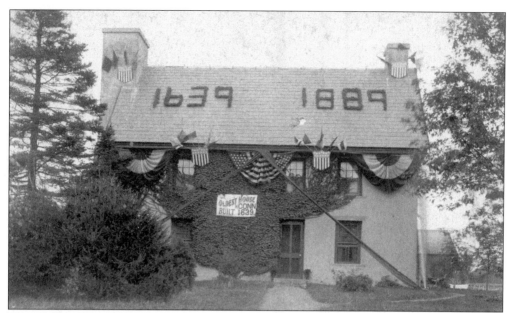

The Henry Whitfield House is shown in 1889, decked out for the 250th anniversary celebration of Guilford's founding. An exhibition of "relics" was held at two houses near the Whitfield House and at other locations. In 1899, the house was purchased for use as the first state museum.

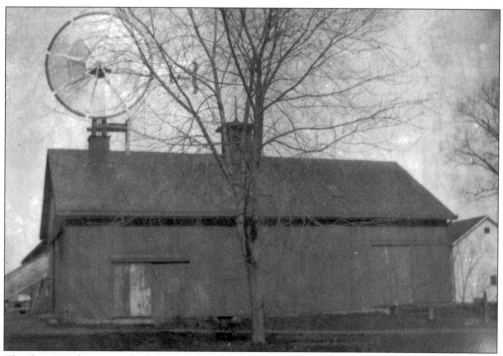

This barn, with an attached windmill for pumping water, was located at the Henry Whitfield House. The property was a working farm before it was purchased for use as a museum. This barn was moved across Stonehouse Lane in May 1905 to become part of Rollin Woodruff's "model farm." The barn still stands today, but without the windmill. (Henry S. Davis.)

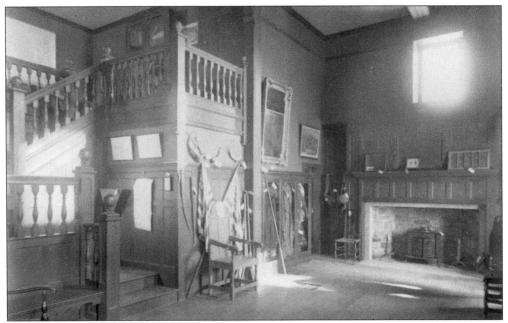

Norman Isham, a well-known architectural historian, undertook the first restoration of the Henry Whitfield House. Because the museum was to display objects from several centuries, Isham made the space suitable for gallery use while adding features he thought appropriate for a 17th-century English manor house. This view looks south. (Oliver B. Husted, c. 1905.)

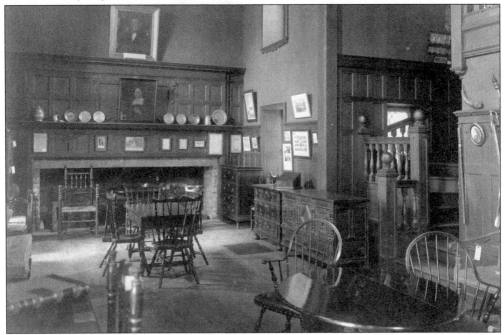

Guilford artifacts of three centuries are shown in this view of the north end of the Harry Whitfield State Museum. In this interpretation, there was no interest in showing the rooms as they might have been used. A later restoration in the 1930s by J. Frederick Kelley returned it to a period house form. (Oliver B. Husted, c. 1905.)

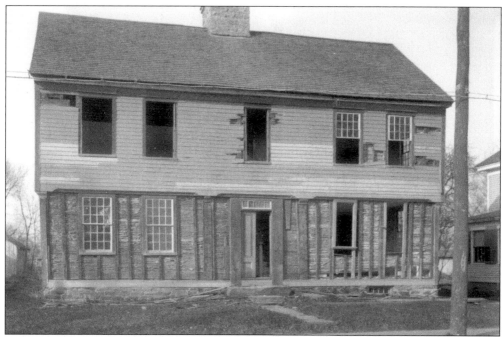

The next major restoration in Guilford was that of the George Hyland House. Although George Hyland's home lot included this land, the house was more likely built by the Parmelee family members who succeeded him. The house was rescued by the Dorothy Whitfield Historic Society in 1913 and was opened as a museum in 1916. In this view, the house is shown with the front clapboards and some windows removed. (Henry S. Davis, *c.* 1916.)

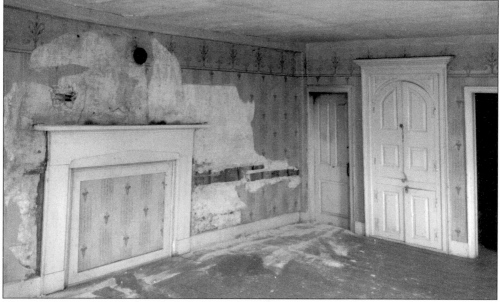

Norman Isham, who had included the Hyland House in his pioneering *Early Connecticut Houses*, was engaged as restoration architect for the project. The east front room is shown here before restoration, with a cupboard that was added *c.* 1760 and fireplace from the early 19th century. (Henry S. Davis, *c.* 1916.)

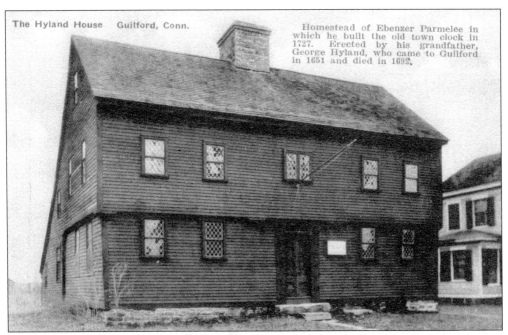

The Hyland House Guilford, Conn.

Homestead of Ebenzer Parmelee in which he built the old town clock in 1727. Erected by his grandfather, George Hyland, who came to Guilford in 1651 and died in 1692.

The restored exterior of the Hyland House illustrates the compromise worked out between Norman Isham and the Dorothy Whitfield Society. Although Isham dated the Hyland House to *c.* 1720, the Dorothy Whitfield Society at that time dated the house to 1660. This dictated the use of smaller, diamond-paned windows. Restoration was a very new field at this time, and an earlier house was often interpreted as a better one. (Henry S. Davis, *c.* 1916.)

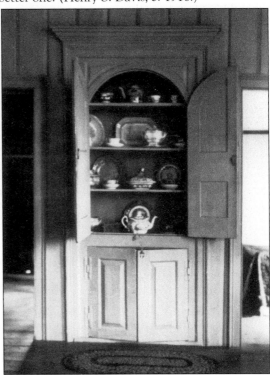

Shown is the cupboard in the restored east front room of the Hyland House. The time period represented by the house called for wood paneling on the fireplace wall and feather-edge sheathing on the remaining walls. Norman Isham therefore added a paneled wall and sheathing in the restored east front room. He planned for this side of the house to reflect 1720, the period when Ebenezer Parmelee lived in the house, while the west side showed 1660. (Henry S. Davis, *c.* 1920.)

119

This basement is known as "the regicide cellar." A plaque on the building explains: "Here in June 1661, William Leete, then governor of New Haven Colony concealed for three days Whalley and Goffe, two of the judges who signed the death warrant of Charles I of England. They were sought by emissaries of Charles II who after the Restoration ordered the regicides beheaded." The cellar later served as a storage space for cider. (Henry S. Davis, *c.* 1920.)

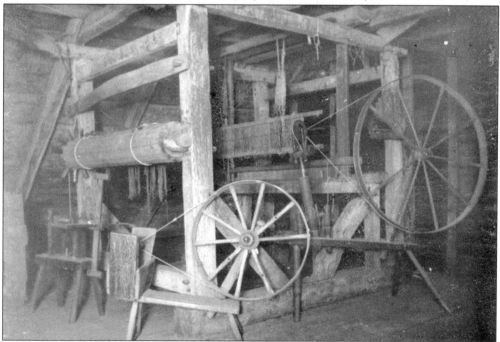

Preservation reached beyond buildings and high-end furniture to tools no longer in common use. Textile manufacturing equipment—a quilling wheel in the center foreground, a wool wheel to the right, and a loom to the rear—is shown in the attic of the Henry Whitfield State Museum. (Oliver B. Husted, *c.* 1907.)

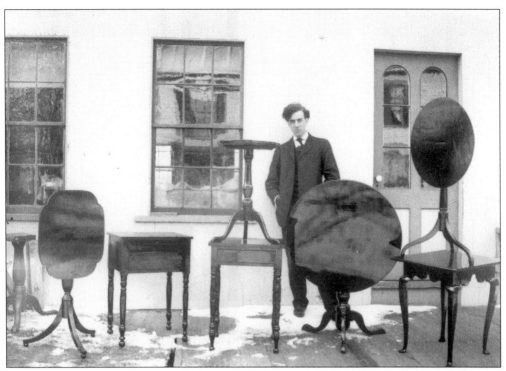

Eva B. Leete began her antiques business in 1892, becoming one of the most highly regarded dealers in New England. Her husband, Edward Leete, had joined his father, Edwin A. Leete, in a carpentry and funeral business in 1879. Their son Earl B. Leete continued both the antiques and funeral business. The business had a workshop, three houses full of antique furniture, and a tearoom. (Oliver B. Husted, *c.* 1909.)

Antiques from the Leetes' shop included silver and ceramics, as well as furniture. This 1828 pitcher may have belonged to Jedidiah Lathrop, who lived in the four-chimney house on the east side of the Guilford Green. (Henry S. Davis, *c.* 1915.)

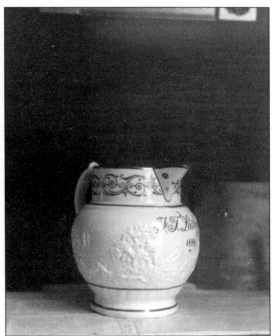

Even with an early and active interest in preservation, some important as well as lesser buildings have been lost. In some cases, progress—highways, public buildings, and more up-to-date homes—has been responsible for razing old structures. The other major cause of loss has been fire, which is a continuing threat to old buildings even today. The John Norton house, which stood at the northwest corner of West Lake Avenue and the Boston Post Road, was built c. 1690 and was razed in 1921. This was the first significant building to be lost after the beginning of the preservation movement. (Henry S. Davis, c. 1915.)

Kimberly Hall on Whitfield Street provided modern office and shop space throughout two thirds of the 20th century. The Shore Line Times, Dudley & Beckwith, and Douden's Drugstore were tenants here in 1915. The building was damaged by fire in 1961 and torn down. (Henry S. Davis, c. 1915.)

In 1915, this house on the corner of Water and South Fair Streets was the residence of the George Bradley family. It was torn down in 1960 to make room for a new post office. (Henry S. Davis, c. 1915.)

The building with the small tower, to the right of center, was the Guilford Free Library until the library was moved to 67 Park Street in 1933. The building was removed and the property is now a parking lot for the Eagle Hose Fire Company on Whitfield Street. (Oliver B. Husted, c. 1909.)

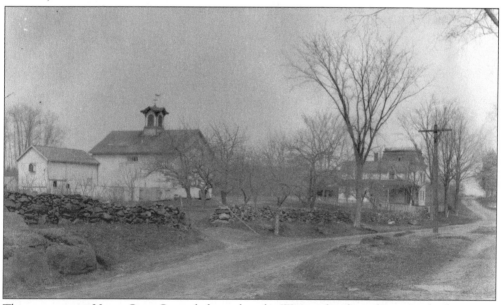

This property on Upper State Street belonged to the Weiner family and remained a farm even after the Connecticut Turnpike was constructed in 1957. However, the highway provided easy access to New Haven, which greatly speeded up the suburbanization of Guilford. The Weiner property became an upscale housing development. (Henry S. Davis, c. 1915.)

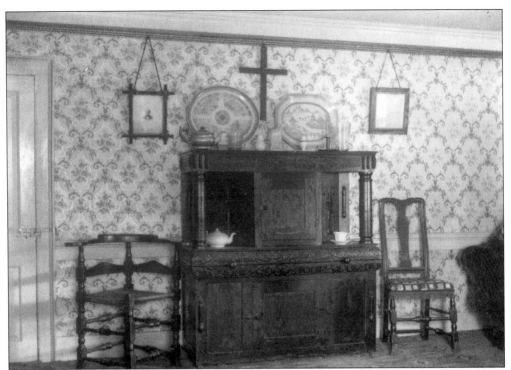

The well-known John Elliot court cupboard, built in Connecticut in the mid-17th Century, survives only in photographs. At the time this picture was taken, the cupboard was still in the Elliot house on the corner of Whitfield and Water Streets. It was later inherited by a family member in North Carolina, where it was lost in a fire. (Henry S. Davis, 1915.)

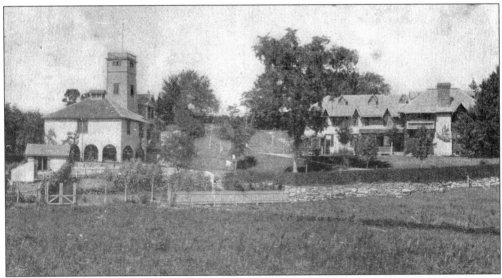

Gablehurst, the only Swiss villa ever built in Guilford, was the summer home of the Chester S. Kingman family in 1897. The property was being used as a private school when the interior was destroyed by fire in 1923. Charles Corbett purchased the property in 1935 and held barn dances in the renovated barn. Although there were plans to rebuild the house, this apparently never happened and the stone walls slowly deteriorated. This image dates from 1910.

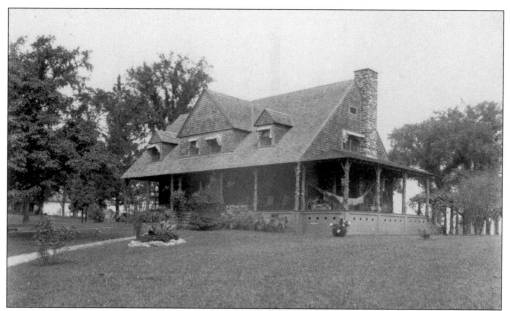

Rollin S. Woodruff, governor of Connecticut (1906–1907), built this Adirondack-style cottage known as Rollwood on Whitfield Street in 1903 as a summer home. The property was a working farm until the 1970s, when the main house and outbuildings were divided into apartments. The house, barns, and adjoining property were under contract to be purchased for use as a museum and artists studio when the house burned in July 2000. (Oliver B. Husted, c. 1909.)

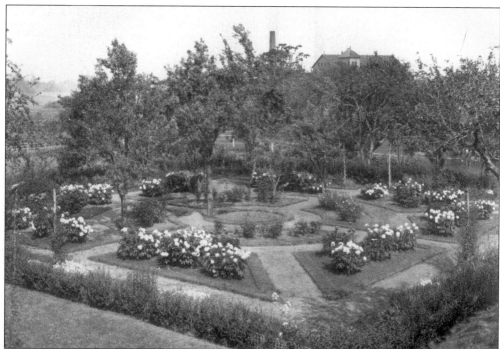

Rollwood once had an elaborate formal garden, shown here with the peonies in bloom. (Oliver B. Husted, c. 1909.)

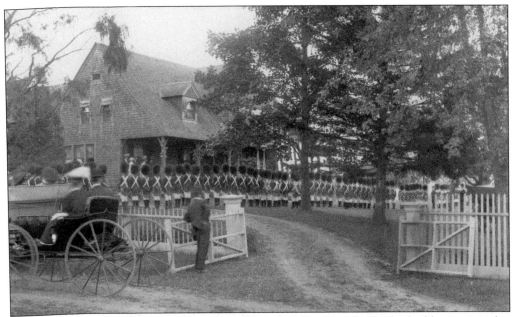

The Governor's Foot Guard performs at Rollwood. Rollin Woodruff, who had been a member of the 2nd Company of the Foot Guard, was probably lieutenant governor when this photograph was taken. (Oliver B. Husted, c. 1905.)

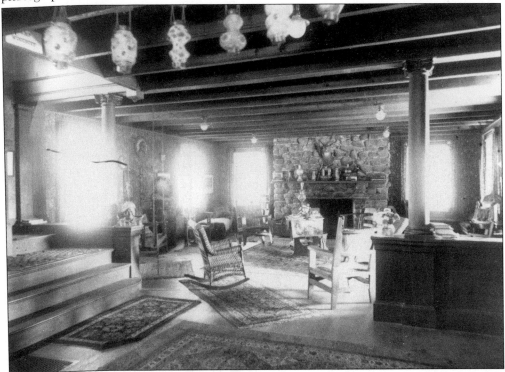

The interior of Woodruff's summer home, with its large stone fireplace, was typical of the Adirondack style. The stone fireplace was the only part of this room to survive the fire. (Oliver B. Husted, c. 1905.)

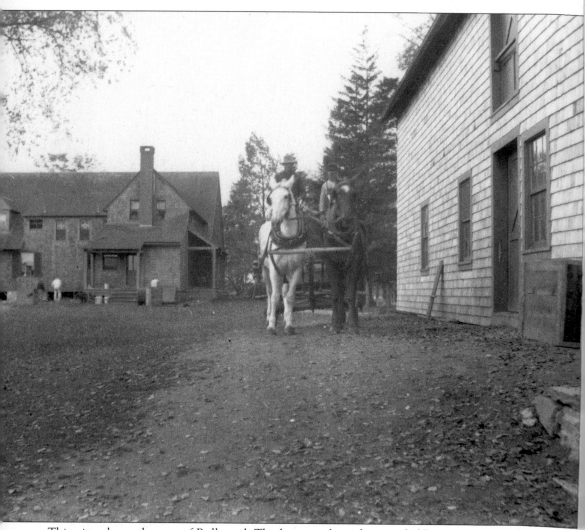

This view shows the rear of Rollwood. The barn on the right is probably one remaining from the previous owner, as it is shown on an 1881 map of Guilford. Rollin Woodruff ran his summer estate as a "model farm," with dairy cattle providing most of the profits. Although the house is gone, the barns survive. (Oliver B. Husted, c. 1905.)